Tunnel Vision

Tunnel Vision

Kevin Breathnach

FABER & FABER

First published in the UK in 2019
by Faber & Faber Ltd
Bloomsbury House
74–77 Great Russell Street
London WC1B 3DA

Typeset by Faber & Faber Ltd
Printed and bound by CPI Group (UK) Ltd, Croydon CR0 4YY

A CIP record for this book
is available from the British Library

ISBN 978–0–571–34008–8

FSC
www.fsc.org
MIX
Paper from
responsible sources
FSC® C020471

2 4 6 8 10 9 7 5 3 1

To my mother and father,
for their constant love and support.

Contents

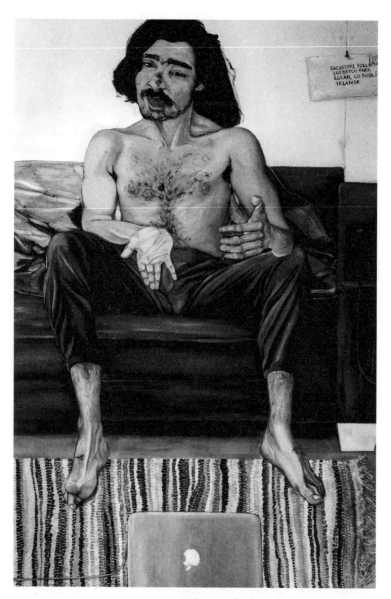

— Salvatore of Lucan. *Me and Ghostie Kissing.*

a way
in the mane
in the main
in arrangements
like Os who like Ozu
I try to take screenshots to show you
my hard drive has fallen
however
and ever
the quake of
the quake of
what corpse are you
shifting ground
town
teeth
to a green outside
this angled repose
on a blanket
Cristiano
in a nest of dears
waiting for his undies
to undie and
no I don't remember
how it fell
but the files
are corrupt
now can't
o pen

Not II

Late in the summer of 1971 – on what must have been a slow train from Leningrad – the enormous head of Karl Marx pulled into Karl-Marx-Stadt, in ninety-five separate pieces. No sooner had the likeness been achieved in Leningrad than the heavy-duty plastic was broken down, fragmented, essentially flat-packed for the trip to East Germany. Sculpted by Lev Kerbel, one of the Soviet Union's most decorated artists, the faux-coppergreen bust weighed over forty tons and, before it was deconstructed, measured over seven metres tall. Considered alone, how many of the parts were recognisable as Marx? Maybe not the nondescript blocks of his voluminous hair. But a chunk of his muscular beard? Was that arched eyebrow immutably his own? Could the philosopher's eye imply the whole? In 1953, this small grey city formerly known as Chemnitz, not far from the Czech border, was renamed after the nineteenth-century dialectical materialist and made a model for socialist theories of urban development. Efforts to reconstruct the bombed-out *Altstadt* were not extended to the 1756 Church of St Pauli. Many of the older buildings fell into disrepair. Suburbs and centre alike were covered in *Plattenbauten*, apartment blocks made of prefabricated concrete, providing affordable living for all. Meanwhile, in the centre, a brutalist high-rise designed by Rudolf Weisser went up. Nothing in Karl-Marx-Stadt looked entirely unlike a cigarette box. Yet here was an architecture that prized function over form; modern, minimal and without affect; an architecture of a utopian future. Over a hundred thousand people turned out to see the Karl Marx Monument unveiled: the head, reassembled and erected on a pedestal, before a section of wall on which the words *Workers of the world, unite!* were carved in German, French, English and Polish. 'The

head of Karl Marx, his brow furrowed before the city to which he had once given his name. But for the dubiously reconstructed neo-Gothic of the *Altstadt, Plattenbauten* were general over Chemnitz, and generally in bad nick. The streets were black with crows, the footpaths brown with leaves fallen from trees I couldn't see. To look for all time upon Chemnitz might drive anyone to drink, but in the gaze of the forty-ton head, I saw only a combination of tenderness, amusement and regret, so powerful in its restraint that, like all statues that belong to a defunct age, it seemed to have its own place, its own weight, one could even say its own silence. On the television behind me, a German news channel was replaying its story about rising levels of the nearby Elbe River. 'Only fifty centimetres more . . .' I heard the news anchor proclaim in all seriousness and doom. What followed after that, I couldn't grasp.

Not III

A bald man with no memorable characteristics except that, with the tense expression of an organism surviving in an alien element, he spoke his nervous yet unbroken Spanish with a thick northern accent so nasal that the movement of his lips seemed like a kind of auto-ventriloquist trick performed as a concession to physiological norms, the director checked his watch. No more than twenty minutes had passed on this, my first day on the job, before he had embarked on what he called 'a quick run-down' of all the major Spanish banks: their founding histories, their traditional clientele, etcetera: information which, he said with the far-off look of a man about to tell a story he has often told before but never as he would have liked, he hoped I would find helpful now the time had come for me to set up a local account. A trial was currently ongoing, he continued, in which eighty-six former executives and advisors of a famous bank, amongst them scores of government and opposition politicians, were accused of possessing so-called *tarjetas black*, ATM cards linked to a secret and unlimited expense account – 'a financial black hole,' he said, 'an abyss' – which had continued to be drawn on even after the ailing bank, since rebranded, had been bailed out by the taxpayer to the tune of twenty-two billion euros. Here the director lowered his voice so that a faint uvular trill not dissimilar to the sound of snoring ran right under it. But given that there was a branch across the street, he said, leaning in, and given that the manager of this branch spoke decent English, the scandalised bank would in his opinion be the most convenient option for me. So slightly did the director move his head forward then that, had the panel of light on its smooth but angular surface not adjusted its position by a quarter-inch or so, there would have been no way for

me to know that this, my first meeting with the director, had come to an end. Two hours later, having delivered an introductory lesson in which I listed seven facts about myself, encouraging clients to guess which of these were lies, I walked into the branch across the street where, having waited to see the manager for almost an hour, I was greeted by someone who was unable to communicate anything to me in English, except that in order to set up an account, at least in this particular branch, I would incur an initial service change of two-hundred euros. I told him I would have to consider it.

○ ○ ○

To a soulless five-bedroom apartment in the south-east of the city, where, with the exception of an incongruously charismatic red rug in the living room, not the slightest trace of anyone who'd come and gone remained, I arrived home late one night to find a few of my flatmates and some of their friends having a party in the sitting room. A man from the city was talking about a private club where it was possible to buy, he said, within the law. I said nothing. But later, in a nightclub, I tracked him down. What is the judicial procedure, I asked him, for somebody caught trying to buy on the street? Just give them the other guy, he said. Otherwise, it's a serious fine.

○ ○ ○

Ten, eleven, twelve floors up, the clerk gestured to the skyline and with a professionally impassive smile, a shade too hard for sadness, yet suggestive nonetheless of something on her mind, some

obscure niggling thing that I could only guess at, she stood there, on the other side of the elevator, in silence. The city was one of distinction and strangeness, a sense of gothic residing in even its modernity, but arriving in this district in the north-east where the client was based, I found myself getting lost in the anonymity of its streets, the absolute regularity of its dingy cafés, dank *floristerías*, inert travel agencies and *peluqueras*, their every window wallpapered with faded images of hairdos not yet old enough to have come back into style. It was only by chance that I'd arrived at the foot of the glass tower, camouflaged by the surroundings reflected on its mirrored façade. There had been a bit of trouble at reception. The silence in the elevator was not a comfortable one, so heavy it seemed to slow down our ascent. The security guard had struggled to understand my introduction above the pitch of his suspicion at this figure – not the usual figure – trying to gain admittance without formal ID. As the security guard reached for the phone, he kept his eyes on me, I kept mine at heaven. By the time all the calls were made, the sky had become the dark bruise the glass needed to give my image back to me. Arriving to escort me to the classroom, the clerk had instructed me to place my bag and coat through an X-ray machine. I had not read the email properly. Full minutes passed. The security guard stared at two monitors. On neither could I see my belongings. Does it normally take this long, I asked? The clerk, as though politely, laughed. Perfectly normal, she said as they emerged some minutes later. With her ring and index fingerprints, she unlocked the elevator door. It was at that point the clerk fell silent.

<p style="text-align:center">O O O</p>

I knew that in order not to miss the last metro I would have to leave somewhat early. Has anyone ever been on a trip to the mountains, I asked. Someone alluded to a view. Okay, interesting. It was a well-rehearsed lesson. Dividing the class into groups, I gave each student twenty minutes to write down TEN THINGS THAT CAN GO WRONG IN THE MOUNTAINS. 'For example: YOU FORGET TO BRING A MAP.' I looked down at my other work, strewn with diverting calculations of how much I could manage to bring in each half hour, working two jobs at once. By the time I invited the class to share their imagined perils in the mountains, all of the clients were long finished, with their eyes dug into Blackberry devices. I stood up and nominated someone to read a sentence, out loud, and very slowly, so that I could transcribe it on the whiteboard with a marker. Okay next. Okay next. Okay next. Teaching the lesson before, I'd picked up enough vocabulary (*cazador*, hunter; *susurrar*, to whisper; *alud*, avalanche) to convincingly imply that, secretly, I could speak Spanish. YOU FORGET TO BRING A TORCH. YOU ARE BITTEN BY A SNAKE. THERE IS A SNOWSTORM. Okay people, I announced, copy all of these down. As usual, it took a long while before everyone had finished. I divided the class back into groups. Turn to a new page, I told them. I want you to trace a line across it.

○ ○ ○

So accustomed had I grown to the night-blue indolence of midweek solitude that most engagements with the outside world, especially before noon, were anticipated as if in a tender spot on my own flesh.

O O O

At last the elevator stopped and fingers slid the doors apart on to an empty hallway lined with dark-blue carpet, so thick and plush I could not hear my footsteps make the footprints I could see. With every sliding door the clerk opened, I wondered: was it possible for fingers to erode over time? For so many door-opening iterations of one's self to corrode it? The silence went on till we got to the classroom, a boardroom like on TV. Propped on an easel facing down a long table was a whiteboard busy with vocabulary: a long list of words left over from the previous week's lesson about asking for a raise. I sat at the top of the table. On the walls no pictures hung. I was thirty-five minutes late. Yet no one was there. Sometimes they don't show up, she said. I'll come back in an hour and check. With that, the door swung shut. Then with a dull crunch reminiscent of a rifle being loaded up, the door locked automatically. Trapped, in very tiny handwriting I reflected on the structure of my loneliness.

O O O

Now using the numbers – you said – the numbers on the whiteboard – discuss how to re-order all the lines in such a way that they form a compelling narrative. The clients weren't stupid: All of them? They could sense what little chance the stories stood of making sense. Yet at this stage you were so familiar with the language, so clear about the procedure – you seemed to know what you were doing: Yes, all. (Every time you did the lesson, the stories always ended up the same: YOU ARE BURIED UNDER AN AVALANCHE.) Fifteen minutes passed before you glanced up from the table. Only three more minutes, people.

I : TRUE

[Negatives and Plates]

Excuse me,
operator,
operator please,
we've been cut
off, I replace the
receiver, the
telephone cord
has already
become tangled
again, and I
become tangled
in it while I'm
talking and
forgetting
myself, it all
comes from
those phone
calls with Ivan.

— Ingeborg Bachmann. *Malina* (trans. Philip Boehm).

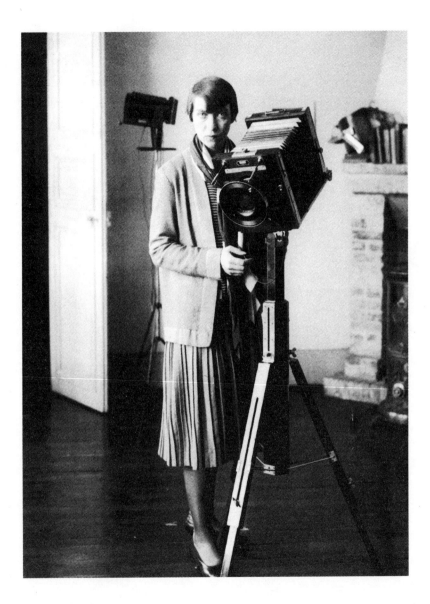

— Berenice Abbott. *Self-portrait with a Large-format Camera.*

Berenice Abbott had just turned twenty-five when, in 1923, after a year studying sculpture in Berlin, she returned to Paris broke, found a job as a darkroom assistant, and was promptly asked by her new boss to remove all her clothes and sit on his unmade bed.

Not much is written about Abbott's life. The same few handfuls of anecdotes are repeated in the largely brief accounts. In 1919 she was hospitalised with Spanish flu for six weeks, after which she had to learn to walk again. More often she is remembered, along with Man Ray and Marcel Duchamp, as part of a trio that used to socialise together in the late 1910s, drinking and dancing in Greenwich Village. Abbott had moved from Ohio to New York in 1918 with aspirations to be a journalist, but her interests soon turned to art and sculpture. Dropping out of college, she took jobs as a waitress and a yarn dyer to pay the rent of six dollars a month on her 'tiny triangular room' in a huge old apartment that was shared by a litany of not-yet-notable figures, not least Djuna Barnes, who two decades later based the main character of her bitterly jealous masterpiece, *Nightwood*, on Abbott's lover at the time, Thelma Wood, a hard-drinking sculptor who is usually remembered as a combination of 'tall', 'muscular' or 'handsome'; unlike Abbott, who is customarily 'thin', 'interesting' or 'pallid' – 'her gaze fixed like the eye of a dazed camera'. They drank in a bar known as the Hell Hole, and remained close after their affair.

On board the *Rochambeau* in the company of Marcel Duchamp and Baroness Elsa von Freytag-Loringhoven, Abbott sailed to France in March 1921 with six dollars in her pocket and almost no French in her head. She had gone to Paris to join the avant-garde, but with the rest of the New York scene yet to expatriate itself, her first months were lonely and uncertain. Details are few, but by the time Man Ray arrived four months later, Abbott had taken classes in the studio of Brancusi and was one of the few English-speakers at the gathering of Dada artists that Duchamp had arranged to greet their friend. That summer, she left Paris with Barnes and Wood – whose relationship had just begun – relocating to Berlin, the queer capital of Europe, where the post-war rate of inflation was making life extremely affordable for anyone who had dollars to their name; Abbott, however, had none. To pay for her sculpture classes at the Kunstschule, Abbott modelled, gave dance lessons and copied decorative sculptures, but she could not afford to heat her room and would often stay in bed to keep warm. She left less than a year after arriving. On her way back to Paris with only a suitcase and the sculpture she'd been working on, she realised she was waiting for the wrong train just as the one she needed was about to depart. She left the work-in-progress where it was. And ran for it. And did not sculpt again.

Berenice Abbott arrived back in New York the year after the Wall Street Crash. Even for her, a portrait photographer of renown, it was difficult to make a living. From 1930 to 1935, she failed to secure any institutional funding for a project conceptually, if not aesthetically, indebted to the archival work of Eugène Atget: to document 'fast disappearing' Old New York. 'At almost any point on Manhattan Island,' Abbott wrote in vain to the New York Historical Society in 1931, as demand for portraits dried up, 'the sweep of one's vision can take in dramatic contrasts of the old and the new and the bold foreshadowing of the future.' Probably Abbott's best-known work from this period is her dramatic architectural photography; much of it taken, after the usual hassle by security, from the upper floors of neighbouring skyscrapers. Abbott's interiors are rare in this period, but these are the subtler, more complex pieces. Taken at a self-service Automat restaurant in 1932, one shows a well-starched man in a trilby hat from behind as he contemplates a piece of pie through a grid of forty-eight locker windows. Shot from a similar angle outside the Lyric Theatre in 1936, another shows another figure, dressed in the same style, standing at the box office, waiting to see Charlie Chaplin. In *El Station Interior*, Abbott gets in closer to the threshold. From in front of a robust metallic turnstile marked entrance, she depicts the art deco landing, where three spectral figures stand by the door, all appearing, in the photograph, distinct. Stilled. Incensed. Solicitous.

She had no sense of
humour or peace or
rest, and her own
quivering
uncertainty
made even the
objects
which she pointed
out to the company
[. . .]
recede into a
distance
of uncertainty,
so that it was
almost impossible
for the onlooker
to see them at all.

— Djuna Barnes. *Nightwood.*

P \| P		P \| P	
U \| U		U \| U	
S \| S		S \| S	
H \| H		H \| H	

In 1919, Man Ray won his first prize in photography for a picture of Berenice Abbott – *Portrait of a Sculptor* – that I have been unable to track down. All I have of the photograph is a description by his biographer Neil Baldwin, who tells us, as though it were to Man Ray's credit, that the shoot took place without Abbott's foreknowledge. 'Rather than ask her to come and sit for him over a period of days, Man Ray took her picture as she looked at him over her left shoulder, capturing the mildness of her eye and the slight petulance on her lips, melding little girl innocence with womanly awareness.' Baldwin's condescendingly gendered ekphrasis reveals a biographer with an eye like his subject, an eye that is apt not to notice the critique of conventional gender distinctions that Abbott and her friends – Janet Flanner, Edna Millay, Thelma Wood, Baroness Elsa von Freytag-Loringhoven, et cetera – all embodied as they moved through the world. For the photographer and his biographer alike, it is always male artists who do the work of challenging gender – playfully, generally in private, and usually through the lens of Man Ray: a domestic abusive wannabe-painter who could not represent a female sitter as anything but a fetish object.

In *Berenice Abbott Naked on a Bed* (1923), Man Ray depicts his new assistant sitting on his unmade bed with her bare arms drawn defensively between her legs and her dazed eyes pointing towards the bottom left, somewhere outside the frame, in an effort to avoid, refuse or deflect the camera's gaze. 'Having a steady job and being dependent on someone besides herself for her income was a new experience for Berenice,' George Sullivan remarks in *Berenice Abbott, Photographer*. 'The situation made her feel uncomfortable.' Man Ray had only hired Abbott because she knew nothing about photography. Yet he made her work such long hours ('doing everything after he took his picture,' says Baldwin) that within a few weeks she had mastered a variety of printing and developing techniques, directing light through the negative onto specially treated paper in such a way as to introduce a more three-dimensional quality to Man Ray's portraits of T. S. Eliot, Matisse, Artaud and the rest. As a trained sculptor, Abbott understood space in a way that her boss did not. She got an early raise from fifteen francs per day to twenty-five. Then a full year later, with several raises overdue, her boss suggested that, instead, she rent out his equipment to earn 'extra' money by portraying her friends on her lunch hour. Taken in his empty studio, Abbott's lunchtime portraits include Djuna Barnes in a black cape and silk turban, Janet Flanner in a top hat with theatre masks attached and Jean Cocteau in the guise of a gangster, wearing a trench coat and a slanted fedora, pointing his pistol at the viewer. Word spread. Commissions landed. Soon Abbott was paying her boss more in rental costs than he was paying for her long hours of labour. In *Man Ray: American Artist* Abbott's name first appears on page 68, right after this

Lugging her large-format camera and cumbersome tripod around New York at the start of the thirties, Abbott was constantly taunted by men. 'Women did not wear slacks then; they wore skirts. When I photographed New York, I put on ski pants. Truck drivers yelled at me, "Lady, take that off." It bothered me. But I found the way was to ignore them, as if they weren't there.' In comparison to Atget's documentary photographs, the tone of Abbott's work is knowing, political, ironic, even blasphemous. The city's statue of Father Francis Duffy – the soldier-priest hero of the Second World War – she went out to shoot before the structure had been unveiled. In her picture, the eight-foot statue is tied up in a blue cloth bag by an intricate bondage of ropes (reminiscent of the chains affixed to the smouldering stake in Bresson's 1962 *Trial of Joan of Arc* after her burning). Standing on a pedestal, in front of a ten-foot marble crucifix, the figure is abstracted, inevitably phallic, a towering corpse in a body bag. To the right of the frame are three depictions of Mr Peanut – the cartoon mascot of Planters Peanuts, a jaunty gentleman-peanut – one above the other, all doffing their straw hats on the large advertising hoarding behind the crucifix. I find it's hard to get a read on the veiled face of that holy statue. As Abbott got the frame set up, a large crowd gathered around her, attracting the police, who threatened the photographer with arrest.

If Abbott posing with her new camera was intended as a gesture of contempt for Man Ray, she never gave much away. 'I made certain not to try and compete with Man Ray,' she recalled fifty years later. 'I went so far as to charge the same price and use completely different equipment.' If he ever saw it, the picture would certainly have communicated their distinct equipment and styles. Perhaps that would be enough for him to feel commercially unthreatened. Newly established at Rue du Bac, Abbott would begin each session – of which she never booked more than one per day – without any plates in her large-format camera. Making covertly false exposures to deflate the pressure of the moment, she would wait until her sitters were at ease and composed before creating any images. Dramatic shadows cast in the service of surrealistic 'mystery' held less interest for her now. To make space for her sitter to give their own account of themselves, Abbott's style became quieter, more austere. In many of the portraits taken over the next three years, she would use the same off-white backdrop and the same dark wooden chair, a plain-spokenly elegant object with arms like musical notations. Portraits in which her subject is not sitting down are rare, but one taken in 1926 depicts Lucia Joyce. Adorned in silver *moiré* scales in a costume of her own design, dancing to Schubert's *Marche Militaire*; her gestures are calligraphic, her body all her own. (Six years later, Lucia Joyce would be committed to an institution for the rest of her life following a diagnosis of schizophrenia that was by no means unanimous.) At the First Salon of Independent Photographs, Abbott's work was highly praised while Man Ray's was panned. Baldwin writes that when Abbott read the reviews, she hid from everyone for a week. In this retreat,

Not long after losing her job, Abbott had gone to see Eugène Atget, the elderly commercial photographer who had previously sold four photos to Man Ray, tentatively allowing them to be printed in *La Révolution surréaliste* on the condition that his name would not be reproduced. (*Don't put my name on it. These are simply documents I make.*) Visiting his studio, just down the street from Man Ray's, Abbott listened to Atget talk about life as a photographer out in public. His large-format camera had taken its toll. He spoke of pain inscribed across his body. Documenting 'old Paris' before it had all been torn down by Haussmann, Atget complained, he had often been accused of being a spy. For twenty-seven years, he had risen early, setting out into the empty streets of Paris, covering ground according to the logic of discrete markets and archival systems: public gardens, train stations, brothels, shop windows, newspaper stands, architectural facades, et cetera. A month before he died in 1927, Abbott took his portrait free of charge: there he droops, a tattered coat, upon a stick. In the years following his death, using money borrowed from art dealer Julien Levy, Abbott would fight hard to acquire the four thousand exposed plates and negatives Atget left behind. Then finally, in 1929, attracted to the skyscrapers constructed in her absence, Abbott returned to New York with her large-format camera, her cumbersome tripod and a great weight of containers.

In 1968, after almost forty years of storage bills, Abbott sold her collection of Atget negatives and plates to New York's Museum of Modern Art (MOMA). Photography Director John Szarkowski used the four volumes of the exhibition catalogue, published from 1981 to 1985, to categorically reinterpret the museum's recent acquisition, considering the work in aesthetic terms – by means of fragmentation, allegory and self-reference – to establish Atget not as the function of market or archival logic, but as a unified artistic subject. Atget became 'the authorizing father' – in the words of Abigail Solomon-Godeau – of a photographic canon based not on the principles of the avant-garde but – in line with the museum's collection – on the 'straight', 'realist' aesthetic of what came to be known as 'documentary photography': a tradition of which Abbott is now seen as a key inheritor; and Man Ray, peripheral, irrelevant.

[Tunnel Vision]

And I was taking such delight in the vision that I forgot to think
about the distress of my whole body . . .

— Elisabeth of Schönau. *Libri*.

The line runs | In this mundane and contemptible existence of mine, few moments fill me with such exhilaration as I feel when, after all the automated announcements have been made, the train creeps from the station and I have not paid the fare. As the platform begins to recede, a primordial fear kicks through me: that one day, when I am caught, I will be thrown off the train and left stranded in some place of which I will know nothing except that it is not where I started and not where I expected to end up. One time, when I told my father about the delight I take in travelling without a ticket, his disappointment was palpable. 'I didn't know my son was a cheat,' he said. Had I expected him to react any differently? It had not yet turned two in the morning, a few months earlier, when the early train rolled out of Bergen Station. I had no credit on my phone and not a krone to my name, but the sky was very blue and my seat was well reclined; and above the Ulriken in the distance, the tallest of the city's seven mountains, that busy old fool, the Nordic sun, was staring straight into my eyes. It was there on the platform that I saw him, the man who has come to haunt my dreams, standing with a child on his shoulders, his right arm waving so slowly that even then he cut an ominous, faintly theatrical figure. As the train advanced up his elongated shadow, I took a deep breath and was surprised to find my nostrils clear. All week I'd been weary with a cold, but committed now to seven hours of free travel, I no longer felt like sleeping. I made a cup of tea and dimmed the lights; I gave my feet up to the coffee table and my eyes up to the screen. By the time my flatmate was out of bed, I figured, the train would be in Oslo, the film quite complete.

○　○　○

Yes, a *film*. What follows isn't set in Norway, but in my living room in Dublin, the curtains drawn across a night sliced into life from time to time by sirens rushing around St James's Hospital next door. So chalk up my introduction as a false start if you like, for the chances of me being kicked off were nil; but as the train pushed on into the shadow of the Ulriken, as the glare of sunlight on the window vanished and the colours of the Norwegian landscape became more distinct and vibrant, the idea that this might be the kind of film that leaves a person stranded somewhere other than where they thought they would be did not seem so ridiculous to me. *Train Ride Bergen to Oslo* (2009) is a film, longer than all but the most ponderous works of avant-garde cinema. Produced by the Norwegian Broadcasting Corporation's cultural station, NRK2, it consists of a single shot filmed on a camera inside the driver's cabin of the no. 602 to Oslo, inhabiting a train's-eye view for all seven hours, fourteen minutes and thirteen seconds of its running time. Much later, when the sun begins to set, the shadow of the locomotive will be cast onto the tracks in front of us, but that's as close as the viewer will come to seeing the train itself.

○　○　○

No sooner had we gone past the slow-motion waving of that father on the platform than we came to the foot of the Ulriken, where two dozen house-shaped houses were arranged as if specially for a postcard, a quaint wooden scene which should have put my mind at

Sarah. I had done this so ineptly, and with so little in the way of explanation, that I'd lost almost all of my college friends as well – even Conor, my closest friend throughout first and second year. A few weeks after Colette and I had begun seeing each other, a distant and not especially well-liked acquaintance of hers called round to her house, looking to talk to one of her elite English housemates. In a tone which may or may not have been intended to conceal the insult, this acquaintance told Colette that her new hair, a cool and slightly blockish black bob, looked like a wig. Colette did not flinch. Thanks, she said, carrying the conversation on until its end. Later, in private, she would curse the acquaintance at length. But in public she began to refer to herself as The Wig, encouraging others to do so too, gradually establishing a whole set of legendary traits and anecdotes for this new alter ego of hers. Colette was really cool. She wore a fur coat, and she listened to techno, and she liked to be a bit obnoxious at times. As a token of nostalgia, she kept a faded old Libertines poster pinned to the door of her bedroom, a room so small that, even at its tidiest, it was always a complete mess: its desk piled high with history books and old, mismatched CD cases; its wardrobe doors jammed open by an overflowing tide of clothes Colette had found in charity shops, many of which, she soon noticed, fitted me. In a photo taken on the night of my twenty-first birthday party, I am wearing a long, geometric red-grey-and-black cardigan of hers and a red-and-white-striped T-shirt that had been left by Conor in the same house at a party earlier that summer. Sitting on the floor surrounded by new faces, I was thinking about how cool this T-shirt looked with my light blue skinny jeans when Bill, a guy I'd met earlier that month, tapped

me on the shoulder and handed me a matchbox full of ecstasy pills. Someone still less familiar presented me with an envelope full of Adderall. Someone else, an entire Parma ham. My two remaining friends from secondary school looked on in disbelief, concern and eventually, I sensed, judgement, before they finally hit the road. So pleased was I to have fallen in with such a glamorous crowd of drug-takers that I had pretty much ignored those two all night. There was no sign of a slicing machine in the house. Cut manually with a knife, the slices of Parma ham came out as chunks that were too rich and thick to consider eating. I don't remember where it was we all went out to that night, only the difficulty with which that two-hundred-euro ham was stuffed into the fridge before we left. And there it would remain, untouched, unconsidered, for weeks on end, becoming discoloured and hardened at the edges, before one of Colette's housemates eventually asked for it to be thrown out. The screen had been black for what seemed a lot longer than five minutes but was not. To the right of the frame, three tiny green dots cut through the darkness, becoming suddenly if only slightly larger until, like that, they were gone. The screen turned black for ten more seconds. Lifting that ham down the steps together, to the black wheelie bin behind her house, Colette had joked that it felt like we were disposing of a body. Up ahead, a stronger light came into view. Left to right, it grew wider, giving the impression of a curtain being either drawn or shut. The light grew ever larger. The tunnel walls gained substance. Now the iron rails within them flickered too. Returning to that intense feeling of duration, at once fluid and poetic, we shot out like a light, back into light, the sky still bright.

○ ○ ○

The shadows at Arna Station were not falling from the foreground any more, but from the right of the frame. Somewhere inside the tunnel, our orientation had changed. Not until we had glided up the enormous length of the platform at Arna would the viewer get any sense of how many carriages were pressing up behind; of how many people and how much baggage might be on board. In the shadow of the station house, a flat-roofed, single-storey building to the right, at least forty people in heavy coats and hats were waiting to get on, but the train had pushed so deep into the station that, by the time it finally stopped, not even the strange old man who'd been standing on his own near the platform's distant end was visible. For some minutes the image remained like that: nothing but the empty platform, the tracks extending out before us, and the mountain up ahead. Here was another static shot, an accompaniment to the static black of the tunnel; and yet, unlike the tunnel, a shot that was entirely cinematic, perhaps some kind of *pure cinema*: either in the Tarkovskian sense of filming time, of sculpting it, or as a Warholian investigation into flatness, deadpan. Though these were the two filmmakers I had in mind before sitting down to watch *Train Ride*, I knew that, formally, it was a throwback to the 1820s proto-cinema of the panoramas, and to hugely popular experiments in 1890s film. According to Patrick Keiller (whose essay on the subject I read in the back room of the JCR, a student cafe where I'd made friends, enemies), not long after they had produced their films of trains arriving at railway stations, cinematographers working for the Lumière brothers and other early filmmakers began to consider 'the possibility of placing their

otherwise static cameras on things that moved: boats, trains, trams, and motor cars. In this way it was possible to extend the spectacle of a film a long way beyond what was visible in a static frame.'

The first film made by placing a camera on a train was probably the Lumières' *Départ de Jérusalem en chemin de fer*, photographed by Alexandre Promio in January or February of 1897 – an oblique rearward view of a station platform from a departing train [. . .] People on the platform watch the train depart, perhaps attracted by the camera. As the platform slips away, some of them raise their hats and wave.

Keiller is interesting on the function of the tunnel in an early *phantom ride* – the name for early films shot from the front of trains. Cecil Hepworth's *View from an Engine Front: Train Leaving a Tunnel* (1899) was one of the first ever films to be used in an attempt at continuity editing.

[Director and producer] George Albert Smith made a studio shot in which a couple are seen from a side-view in a railway carriage compartment. The window is dark, as if the train is in a tunnel, and the couple (Smith and his wife Laura) take the opportunity to embrace and kiss. [. . .] Hepworth's film begins with a view from a stationary locomotive facing a tunnel entrance. A train emerges from the tunnel and passes the locomotive with the camera, which advances into the tunnel until the screen is entirely dark. At this point, Smith cut in his railways compartment scene, which is followed by the remainder of Hepworth's film –

a moment of darkness in which a point of light appears and widens until the train emerges into daylight. The film's publicity took care to assert the propriety of the scene depicted, though viewers must surely have been aware of the dangers, real or imagined, that accompanied travel in isolated railway compartments.

When *Train Ride* was acquired by Netflix in 2016, Allison Picurro, an online-television critic for *Decider*, described the film as a kind of 'visual Xanax'. Nowhere does Picurro explain what she means by this comparison to the popular anti-anxiety drug; but if cinema is, as Alain Badiou has it, 'the high point of an art of identification', I guess the basic idea is that, by watching *Train Ride*, the viewer is given to identify with a subjectless gaze. Thus narcotised by a screen on which lakes and mountains, rural towns, snowy wildernesses and nowhere stations sweep past with no particular focus paid to anything at all, the viewer withdraws from selfhood, all anxiety disappearing until the train pulls in at Oslo Central – where we alight back into . . . what exactly?

O O O

One morning not long after my birthday, sitting beside Bill on his bed in his room in Rathmines, I was grinding my student card back and forth across a plate, crushing up ten of the three hundred extremely low-grade ecstasy pills he had invited me, one day, to go halves on. So common had it become for us to stay up for several days straight, drinking, snorting pills, talking shit, that we'd started to grow bored of it. Our intention in crushing up not one or two,

and surrounded by wolves. The main difficulty was Norway's topography: to travel from Bergen to Oslo involves crossing the vast nameless mountain range that covers about nine tenths of the country. Where it was impossible to lay the line over an elevation, it would be necessary to dynamite through it. On the line's current course, there are 182 tunnels, the longest of which is over ten kilometres. In the original version of *Train Ride*, every time the camera entered the darkness of a tunnel, the film cut to archive footage of the railway being built. But in the version I was watching on Netflix, those cuts had been removed. Instead, every time the train entered a tunnel of any significant length, a crude blue graphic would fall from the top of the screen and linger there for a few seconds. In a basic sans serif, this graphic gave the name of the tunnel, the year it opened and its length. Before sitting down to watch *Train Ride*, I had scrolled through the comments on YouTube (where the film can also be streamed) and read a number of complaints about the gong which sounds whenever these signs come on screen. 'They kill the relaxing part of the experience,' says Rihards Lacplesis. He's right. They feel like an alarm going off at exactly the moment before you fall asleep. The thought that these sounds would continue throughout the trip was causing me to tense up. I would not be able to forget myself this way. In search of a solution I returned to the YouTube comments, where someone called Rhythm Assisted Poetry suggested muting the film and playing the audio from another train film, in another window. But even if it were not impossible to sync up the silences of the two trains at their various stops; even if the onboard announcements could somehow be made to

glowing, we poured the contents out onto a mirror and sliced out two thick lines. Straight after snorting the first one, Colette cursed the pain of it shooting up her nose. Like snorting glass, she said. Okay, I said. But do you feel anything off it? No, she said. Not a thing. Crouching down towards my line, I feared we had spent all our money on nothing-much. But before I reached the end of it, I heard Colette roaring at the ceiling. I am fucking *fucked*, she cried. Pretty soon I was fucked too. It took us a couple of weeks to finish the stuff, by which time mephedrone and other new, therefore technically still legal, white powders had become available in head shops around the city. Most of them were as dodgy as their names suggested: Hurricane Charlie, Vanilla Sky, Annihilation, and so on and so on. No additional information was ever provided regarding the contents of these packets, but whatever mephedrone they contained had obviously been stamped on with something else. Often faintly brown, brittle, clumpy, the powder was softer and less granular than in its online version: it always stuck to the card as we were cutting lines and it was nowhere near as potent. But since there was a shortage of MDMA in Dublin that summer, and since both of us were scared of making another order through the postal service, we ended up buying quite a lot of it, hoovering gram after gram of these unknowable substances into our bloodstreams, rarely achieving euphoria. It was often quite unpleasant. One tiny bump of a brand we'd never tried before had been enough, one Friday night, to prevent us from sleeping the whole weekend. Colette's cheek had begun to twitch as soon as we had taken it, as though a fishhook were caught in her upper lip. Several frantic hours of online research led Colette to conclude, by Saturday afternoon, that

the powder was reacting with the antibiotics she had been prescribed earlier that week. Yet still, that twitch remained an ominous concern. Not until late Sunday evening did we finally get to sleep.

O O O

At the gates of the level crossing between Herland and Songstad, no cars or trucks or bikes or even people were waiting on either side of the track. A solitary raindrop appeared on the windscreen, inching down very slowly before the next batch of tiny tunnels appeared: Romslo II, 377m; Romslo I, 581m. Darkness. Light. Darkness. Light. Some weeks before our mephedrone had arrived, I asked Colette what the effects of her perfect imaginary drug would be. Though her answer would become a joke we often referred back to, I don't think either of us really gave it much thought at the time. She said: tunnel vision, a slow strobe effect, and an unstoppable twelve-hour erection. By the time the train emerged from Romslo I, the raindrop had vanished, and in the instant before we entered the next tunnel – Rimses III, 216m, another short one – I saw a small row of houses on the area of land above it. How many people in those houses had just sat down to breakfast? How many heard us passing underneath?

O O O

Imagine my delight when, with term now recommencing, I found out that someone I knew had started ordering mephedrone online – the real stuff, by the kilogram – and could be contacted at almost any time with highly attractive rates: €20 for a gram, €150 for ten. We took it

almost every night we went out, plus some nights that we stayed in. Everyone was doing it, even those you wouldn't expect to. In certain circles, it was thought to be a dirty drug, but I never understood why exactly. Was it its price? Its popularity? Its legality? The uncertainty concerning its long-term effects? Was it that mephedrone had been designed to merely *simulate* MDMA and cocaine? Or was it mephedrone's aphrodisiacal side effect – the one we only ever acknowledged to each other tacitly? Two lines of mephedrone gave me an erection of a categorically different order to those I had felt before, a rock-hard purple erection, an erection with an engine behind it, remaining highly sensitive and desirous, and yet, thanks to something called vasoconstriction, an erection totally incapable of reaching orgasm for as long as there was still mephedrone lined up.

O O O

As the train emerged from the tunnel after Myrdal, I recalled a still I'd snapped some years before, a shot from *Man with a Movie Camera* in which its protagonist, the film's cinematographer Mikhail Kaufman, is pictured from behind, his body sprawled across a set of railway tracks, his ass in the air, as he takes a very low-angled shot of a train oncoming in the distance. Directed by Dziga Vertov and edited by Elizaveta Svilova, *Man with a Movie Camera* is a film made in the constructivist mode. The opening intertitles proclaim that this experimental film – a portrait of a composite Soviet city – 'aims at creating a truly international language of cinema based on its absolute separation from the language of theatre and literature'. With innovations like montage, split screens, stop-motion animation

pockets inside out to see what we had left, pouring that onto a plate. Colette closed the shutters. Colette turned the lamp on. Time passed. Time did not pass. In that tiny room, on mephedrone, sex became a different kind of space, a space in which to spread ourselves, a space in which to luxuriate, a space where, at any given moment, it could be morning, noon or night outside. Colette was responsible for cultivating a sense of sensuality in me. She had taught me to go slower, she had imparted a certain patience, a patience which we both pursued, both sought to extend. Whenever it seemed like I was close to coming, we would slow down still further, then stop, then snort another line, suspending both orgasms for another half hour or so. I did not find this frustrating. It was not an orgasm I was seeking, but the continued build-up to one. As well as quickly, slowly; as often as with vigour, with sloth; we learned to fuck each other in a totally unhurried way, starting and stopping and starting again, holding and being held down, talking to each other throughout, fucking variously, fucking listening to music, to Colette's favourite album then: *Fabriclive 36*, compiled by James Murphy and Pat Mahoney, a luxurious blend of disco and tech-infused funk, the kind of music I had no knowledge of or interest in till I started seeing her. After so many hours without sleep, the two of us would start to hallucinate. That was not surprising. What was strange is that we both saw the same thing: a tangle of lines squiggling across the ceiling, like a spider weaving its web, fast-forwarded. You liked the fragility of those moments suspended in time. At the foot of the bed, the left side of Colette's wardrobe was papered with glossy photos of all her friends, arranged with no gaps in between. I remember those faces so clearly. Once, when Colette was on top, her face

in my neck, I caught sight of one of them. So late into yesterday night, this face appeared to be watching me. I didn't mind at all.

O O O

In his essay on Sergei Eisenstein, Roland Barthes introduces the idea of *the filmic* as 'that in the film which cannot be described, the representation of which cannot be represented'. It is in the filmic, he writes, that the 'obtuse' meaning of the film resides; a meaning which is 'the epitome of a counter-narrative'; a meaning which cannot be grasped 'in situation', 'in movement' or 'in its natural state', but rather in 'that major artefact, the still'.

Since reading Barthes's essay four years ago, I have kept up the habit (annoying to some) of pausing any film I'm watching the moment an intriguing or pleasurable shot comes on screen to take a screenshot. My library of screenshots is large. It contains over two thousand film stills. Several times I have tried to write about these artefacts, but it has never worked. Now, in a fairly transparent effort to construct a public image for myself, a cultural identity, I mostly just post these stills to Twitter. I continue to seek them out, though, in the hope (sincerely held) that one day, some meaning will present itself to me.

Owing to the speed at which the train had been sweeping through the Norwegian landscape, it was proving extremely difficult to make a still from *Train Ride*. Very little could be taken that wasn't blurred everywhere but the centre of the frame. Unless the train was stopped at an empty platform, or unless the train was in a tunnel, there was no stillness to these stills.

And then, as the train approached the end of Skeien II, a tableau

appeared on screen in which, with most of the frame still cloaked in the static darkness of the tunnel, the intense blurring that had so far ruined all but the emptiest end-of-platform shots was easily avoided. At the centre of the frame, occupying about 5 per cent of the screen, the tunnel's exit admitted enough light to give substance to a small section of the railway tracks ahead. Two faintly curved parallel lines, materialising ten feet from the front of the train, drew the viewer's gaze towards the exit: a pentagon of light, a frame within a frame in which, at a squint, I could just about make out a tiny *mise-en-scène*: a road, a lamppost, a hazy yellow sky, and a single car, travelling in the opposite direction to the train, pictured at the angle cars are always depicted at in television advertisements.

I took the screenshot, created the still, then posted it to Twitter accompanied by a short caption: *And there in the distance, a road.* Though the car is not without its own romance, I never considered mentioning it. I do not drive. Neither do any of my friends. If I'm ever in a car, it's usually with my family. For me, the car speaks only of family. I imagine it's my parents who are in it. For Barthes, the value of the still lies in the lack of a 'diegetic horizon'. Yet here, as if in a sequence from a bad dream, I envision the car driving out of the frame, gone before I get out of the tunnel.

○ ○ ○

I did not know what to call the tunnel that came after Myrdal. For although the gong rang out and the blue graphic appeared, the tunnel's name was not displayed. 'Mellom Myrdal og Finse er det 34 tunnelar' was written on the sign instead. ('Between Myrdal and

I would stop showing up. It was pointless. I could do the reading on my own and my essays would be unaffected. And maybe that would have been true. Who can say? I never wrote the essays. I wrote a novel instead. Or so I said, to pretty much anyone who would listen. Family. Friends. Enemies. Colette. In truth, I had not written a word of any novel. I didn't even have an idea for one. In the smoking area of every nightclub in Dublin, I would explain that the novel was in need of complete restructuring: I was planning a thorough revision of it soon. Me and Colette and a few others went out dancing every Friday and most Saturdays. Now that our supplier had started doing deliveries, everyone seemed to be taking more mephedrone than ever. And though almost every week we would have to remind them of our names, we were now sort-of part of the cool after-party crowd. I heard a lot of talking at those things but I cannot recall anything that anyone ever said. Usually around seven in the morning, whenever our unknown hosts became more selective about who was still welcome, a few of us would head back to Colette's or Bill's house. One dark morning in Bill's sitting room, the three of us had been up drinking and snorting mephedrone for several hours when Colette – half asleep on the couch and quite aware that I was not yet ready to leave – asked Bill if she could use one of the bedrooms that were spare upstairs. Splayed across the rug, presiding over the plate, Bill smiled up at her and nodded. 'Help yourself,' he said in a tone betraying his relief and pleasure that he was not about to be left alone for the afternoon. He poured me another drink, lay back down on the rug and after a brief silence, he smiled at me. 'Well,' he said. With the rolled-up banknote in his hand, Bill pointed to the plate on which he'd laid out two fresh

lines of mephedrone. 'It's just ourselves now.' I looked at him and nodded, crawled down off the couch and propped myself up on the rug. There was only the plate between us now. After snorting my line, I removed the note from my nose and noticed that the tip of it was moist and slimy. Without saying anything, I passed it back to Bill and watched, transfixed, as he slowly inserted this moist tip up his own nose and, with the help of his muscular hand, pushed it up the length of the line. Though we had told each other secrets in the past, it was a matter of considerable surprise and confusion to me, when, after a few seconds, for reasons I would not comprehend until years later, I found myself in the middle of telling Bill a story from a shadowy region of myself: about a sexual encounter that I'd had, a couple of years previously, with a man. When I told him this, Bill laughed. He did not believe the story and insisted I come clean. He insisted I admit it was a joke. I told him it was not: a couple of years ago, I had fucked and been fucked by a man I knew. 'Are you trying to tell me you're gay,' he said; his monotone doing nothing to disguise his panic. Of course not, I told him in nervous retreat, with sudden incredulity. I insisted I hadn't really enjoyed the experience; and since I couldn't stand the silence, I went on, reassuring him that, whenever I had groped the man's body, my hands had naturally gravitated towards his ass, which felt almost the same as a woman's ass, compared to his chest at least. With his eyes stuck fast to the plate, Bill ordered me to stop. 'You've told your story,' he said. 'You don't need to describe it to me.'

O O O

The gong was back, all the louder now for having spent some time away. Opened in 1993, Finsetunnelen is the longest tunnel on the line. Inside it, a sequence of twenty brownish lights affixed to the tunnel's right wall swept back out of the frame, one after another, disappearing quicker than the electricity poles outside. Then the tunnel went dark again. For ten kilometres, it stayed that way.

○　○　○

One wet, dark Tuesday afternoon, on the fourth floor of the Ussher Library in Trinity, I was pretending to work on my novel when, with no premeditation, I decided a more productive and interesting way to spend the next few hours would be to take mephedrone in the National Gallery. I texted our supplier and, when I went downstairs to meet him, I told him not to mention it to Colette. Walking up the stairs of the gallery, I had one gram in my pocket and another one dissolved in a bottle of water. Fearing that its metallic smell would be recognised by an attendant, I gulped the bottle down in haste. By now I was immune to its foul metallic taste. I do not remember anything from the paintings I looked at that Tuesday afternoon, except a shirtless figure hunched behind a tree, his eyes addressing the viewer, his hand pointing behind him to a distant silhouette. At some point there had been a change, a quick and silent displacement going on in some part of myself, something coming apart only to reconfigure itself otherwise. I was not experiencing the profound insights I had told myself to expect. I had lost control of my limbs and had begun to feel ecstatic, self-conscious and bored all at once. I walked briskly down the stairs and out of the gallery. I went into

a small family-owned art auctioneers a few doors down and started talking to the man working there about the paintings on display. I have no memory of them, except that there were too many and they were all too brightly lit. Affecting the air of a person who might be interested in acquiring art for a collection, I pointed to one and said it looked like Klimt. Did it? I did not know very much about painting, but for years a reproduction of a Klimt landscape had hung in my family home. Either the man didn't notice how fucked I was or else he pretended not to. In any case, I remember he agreed with me. We talked for something like half an hour, but I have no idea what I could have said to him. After I left, I went to the Centra across the road and bought a copy of the popular softcore lads' magazine *Nuts*. I folded it over, put it in my bag and briskly headed for Pearse Station.

<p style="text-align:center;">o o o</p>

As the train was coming towards the end of Finsetunnelen, the daylight glazed the arch made by the roof and walls, thin strips of wood covered in ice and frost, forming a psychedelic cloudy-blue pattern that was suggestive of a halo at the centre of the screen. The act of leaving this tunnel affected my lungs like a vapour: they felt clear in a way they had not when, three hours ago, I pressed play. Including the impressive train station, I counted sixteen buildings in Finse, the highest point on the line. To the right, a lake shimmered in the afternoon light without disguising the fact that its colour was dimmest grey. 'There's something muted about grey, undemanding,' says the narrator of Hanne Orstavik's *The Blue Room*, a beautiful novel published in 1994 about a student in her

twenties who lives with her mother in Oslo. 'I like it. It absorbs all the other colours into itself, takes its place at their side, is loyal.'

○ ○ ○

Every weekday in the summer of 2000, me and my friend Peter set out to one of the two newsagents that fell within the territory where we were permitted to roam; and there, as though we were fulfilling a chore, one of us would buy a copy of the *Sun* for the picture of a topless young woman that appeared each day on page 3. Always careful to request a plastic bag in which to conceal it, we carried the tabloid up the horseshoe-shaped cul-de-sac on which we both lived at the very bottom. When the road began to veer right, the two of us veered left, stepping over a stepped-on fence into a ditch full of nettles, which was intersected by a swampy, unmoving stream of something we both believed to be sewage. The rock we used to cross the stream was steady but extremely slippery and dangerous; and once across the stream, we still had to struggle up an eight-foot mound of wet ground, clear the leaves we'd scattered there the previous day and dig shallowly, before unearthing the damp cardboard box, once containing snooker balls, in which we kept our collection of smiling topless models presented with no context other than their age and their first name. After we had torn out our most recent acquisition from the paper, we removed the others and, on the half-sodden dirt in the ditch, methodically prepared the scene in which to add it to the collection, in ceremonious rows. On our hunkers, in unison, we stared from one photo to the next, starting with the

new girl, smiling in the bottom row. Aside from the occasional remark about a pair of breasts, the two of us were silent.

O O O

I got off the train and for the twenty minutes it took to walk home I thought and thought about the glossy palette of the magazine in my bag. At home, I went straight up to my room and, laying the magazine open on my bed, I poured the other bag of mephedrone onto a large dark hardback edition of Susan Sontag's posthumous essay collection, *At the Same Time*. I divided the contents into twelve lines. Then taking off my trousers, pants and socks, I snorted a line with my rolled-up train ticket. Sitting over the magazine in just a T-shirt, I jerked off for a while, stopping only to snort another line, turn the page, or adjust the position of my bedside lamp and with it the glare of light on the paper. Two years before, in the Gare du Nord in Paris, I had bought some French equivalent, but I think this was the first time I'd bought *Nuts* in Ireland. I liked the idiotic but unthreatening way the magazine made the women appear to speak to me. I liked the way the pictures were staged and how the accompanying interviews seemed so familiar. These women seemed so unconditionally friendly and happy and available. But, with only two or three images on any given spread of pages to project a fantasy onto, and my prostate constricted by mephedrone, I had a hard time dreaming up a vivid enough scenario to get me even close to coming. After about half an hour, I decided this wouldn't do. I put on my pyjamas. I went downstairs. I found a scissors in the kitchen. After locking the door to my room again, I cut from

the magazine all my favourite pictures, noticing sometimes that, as I did so, on the back, within the frame I was cropping, another body, often belonging to the same woman, was being sliced through. Though I laid these images out on the bed in rows, at no point was I reminded, for I was not yet ready to be reminded, of the exhibition Peter and I held every day throughout the summer of 2000. Did neither of us have any idea how to masturbate at the time, or even that such a thing existed? Perhaps we were just too bashful to do it in front of one another. One day that summer, bored of our ritualised looking, we improvised a way of rehearsing intercourse. Into the side of the mound of earth where we interred our stash, we dug a large hole with our hands. Peter then used some instrument that he'd found to cut a hole with roughly the same circumference as a tennis ball into a sheet of cardboard that I'd found. Across the darkly dug hole we laid the cardboard down. With our dirty hands we selected a favourite picture to be placed a few feet above the hole. We weighed the picture down with two small rocks. We agreed that I would go first. Peter turned around. I got down on the ground, checked to see if he was looking, took my dick out of my trousers, and fucked the wet black hole.

O O O

Ten years had passed since that summer with Peter. I had become a collector again, a lone operator now, it's true, but still specialising in the same material: softcore topless images which I methodically cropped from the kind of magazine I was embarrassed to purchase on a number of levels: occasionally from *Playboy*, but mostly from

lad magazines, such as *Nuts* and *Zoo*, a phenomenon of noughties print culture dedicated to what Andrew O'Hagan described, in his essay on the form, as 'the rough magic of being a bloke'. In all the hours I spent jerking off to these images while vasoconstricted on mephedrone, I don't think I came more than once. Then my parents got wireless broadband installed in the house. After that, things changed. The image was static and silent no more. Now, there were twenty-four frames per second. Now, there was audio. The train was getting faster. I heard it beating against the rails. From this point on, I availed myself of our supplier's €150 offer as often as I could. He agreed to help me keep the scale of my purchases a secret from Colette. On a Monday or Tuesday, I would pay him seventy euro in exchange for six grams, so that, when Colette and I arrived on the Friday, our order of four grams did not appear discounted. I spent a lot of time at home now. My hair grew very long. With the curtains drawn, I sat up in my room, ostensibly studying, my face turned pink with the glow of my Incognito browser tabs – a function I chose as automatically as I'd requested a plastic bag in which to hide the *Sun*. Concealed beneath an A4 sheet of white paper, twenty strategically measured lines obscured Sontag's face. Most of the porn that I watched in these sessions was from the 'Most Popular' sections of the websites I used. The women I chose to see being fucked by men – usually quite athletic bald men to whom I could not relate, and yet from whom I never achieved any distance in terms of identification – were the ones whom, on average, everyone else chose to see being fucked. For twelve hours in my room, so hot that the window and mirror would steam up, I jerked off to this aggregate of heterosexual desire, pausing only

couple kissed, all too briefly, open-mouthed and wet, waiting for the moment when the woman's hand would reach down, stroking the shaft of the man's dick through his cargo trousers; then, just as the woman fell to her knees, before she had unbuttoned or unzipped those trousers, trousers of a sort I would never wear, I would pause the film and move on to another tab to watch another variant of this ceremony, usually performed by a different woman and a different man, but often, I came to notice, in the same room of the same beach mansion. Watching as many as ten films at once, all in coterminous stages, I would arrive at all ten cumshots in sequence, more or less.

○ ○ ○

The snow didn't disappear suddenly, but over the space of an hour or two. The terrain was getting flatter; the train was in the process of descent. We started to see grass. We started to see trees. By the time we left the station at Flå, we'd started to see orange and yellow and green. Oak trees, silver birch, sycamore and fir – or so a friend informed me on Twitter. Personally I do not know the names of enough trees. *I do not know the names of enough trees.* For a while this was what I would say whenever anyone asked me about the novel I was rewriting. I'd stolen it from a French lecturer who had said it in a tutorial on *Madame Bovary*. After exclaiming on the number of trees that Flaubert could name, the lecturer sadly declaimed that he had always thought he would have made a great novelist himself, only he did not know the names of enough trees. Whenever I repeated it, I felt like such a fraud, but it always got laughs and served the purpose of lowering expectations

as well as conveying a displaced representation of the truth. It was a metaphor. A tree to hide behind or within. That is what trees do. That is what they do in *Madame Bovary*. That is what they do in 'Wild Swans', a story by Alice Munro about a young girl who, left unsupervised in a train compartment, is discreetly and without consent fingered by the man sitting next to her. 'In lieu of genital description,' Maggie Nelson notes about this story in *The Argonauts*, 'Munro gives us landscape: the view outside as the train hurtles forth, which the girl beholds as she comes.'

O O O

Since first airing in 2009, *Train Ride Bergen to Oslo* has been viewed, at least in part, by over 45 per cent of Norway's population: that's more than two million people, or roughly four times the number of copies that Karl Ove Knausgaard's immensely popular six-volume memoir-novel has sold in the same market to date.

O O O

I stayed over at Colette's less, spending most of what money I had on mephedrone, bingeing once every week or two, beginning to seek out the most popular films with titfucking in them. ('Man dreams of putting penis between girl's boobs,' writes John Ashbery in *The Vermont Notebook* (1975). 'Is all mankind diminished? Or strengthened? What do you want?') As I worked my way through to my final line, I would scan through all the tabs I'd had open all night, decide which I'd most enjoyed the final half hour of (usually

a film with titfucking near the end); and then jerk off to this footage to which I'd been jerking off in fragments through the night. After coming, there was only enough time for me to close the windows, wipe my sweating, cum-soaked chest with a sock that I'd prepared, and place the laptop on the ground before I would fall straight to sleep, an entirely dreamless sleep, a duration of featureless darkness that felt like ten seconds but was always four, five hours. I woke up for long enough to go to the bathroom, pee and down a glass of water. My muscles were aching. My dick was sore, misshapen and alienated. My bedroom was hot. After opening the window to clear the steam on the mirror, I'd go to sleep for real, waking up in sleep paralysis.

O O O

In one of *Sans Soleil*'s most cinematically impressive and culturally problematic sequences, Chris Marker establishes a metaphorical correspondence between the Tokyo subway and the cinema by showing crowds of people in a subway station, buying tickets which 'grant admission to the show'. Passing through the turnstiles, they each hand over their tickets before the film cuts to a cartoon made from the perspective of the front of a train at night, precisely the perspective of *Train Ride*, which in turn is followed by actual footage shot from the back of a train, the rails receding into the distance. Marker juxtaposes these two shots, dramatising a dialectic of past and future, before the film cuts to a shot which, except for the occasional reflected contour of the cameraman in the bottom of the frame, we are refused in *Train Ride* – that is, the inside of a carriage. The film cuts between portrait shots of people sitting in the subway carriage, most of

them asleep, before a sequence of still images from Japanese film and television is introduced. Variously horror, samurai or pornographic in nature, these images are presented in such a way as to suggest that they make up the contents of the passengers' dreams. 'I begin to wonder if those dreams are really mine,' the narrator reports, 'or if they are part of a totality, of a gigantic collective dream of which the entire city may be the projection. The train inhabited by sleeping people puts together all the fragments of a dream, makes a single film of them, the ultimate film.' A long time passes without narration.

O O O

For years my dreams were often filled with encounters, erotic or otherwise, between me and women who I knew from porn; while by day, if I closed my eyes to think for more than two or three seconds, I would involuntarily visualise an unstill scattering of film stills, a moving collage of porn images which, though I could never recall having seen them, seemed nevertheless familiar to me. Uncanny, unfriendly, often frayed at the edges, these fragments, these virtual ruins, would come darting en masse towards the frame of my mind's eye, swept up like leaves in the wind, passing out of view so fast it was never possible for me to look at them closely; to grasp them; to fantasise onto them. These images made me realise I was watching too much porn; at the same time, they also tempted me to watch more, just a little more. When mephedrone was banned in Ireland, I drank more, tweeted more, despaired at my expected grade more, and in secret took whatever pills were around, mostly Valium, given to Colette by the guy who had stopped selling mephedrone

since his UK supplier refused to continue delivering it through the post. On the couch in Colette's new apartment we would stay up together watching TV until, inevitably, Colette would fall asleep and I would take a couple of Valium from the brown envelope in her room, grab my third beer of the night from the fridge and watch Vincent Browne with Twitter open. Without allowing myself to notice it, I had been presiding over the destruction of my own sexuality. I found it impossible to fantasise about anything that was not a pornographic image. Yet in the absence of mephedrone, my experience of porn had returned to its former pattern, where I would come after three minutes, or two, or sometimes one, then continue to watch for another thirty seconds, before I felt so bad about myself I had to close the window. It all stayed far too fragmentary for me, but I continued to watch it, and with some urgency. Just noticing myself opening an Incognito window would send a warm and welcome wave of dopamine crashing through me. I found it difficult to get an erection in the absence of pornography. I felt no desire for Colette any more. I felt no desire for anyone at all. On the rare occasions Colette and I had sex, I would press my face into the pillow and try to visualise some porn.

O O O

On the train into town one day, I answered a call from an unknown number and was told that I had won tickets to see Nick Cave's side project Grinderman; it turned out Colette had entered me in a competition. Colette was away that weekend, so I invited my friend Ross instead, and on the morning of the concert I picked up five

ecstasy pills in Ringsend. When Colette was going into her final year, she had stopped taking drugs and insisted that I stop taking them as well. A couple of months before, Colette had complained we no longer had sex unless we were on drugs; I did not want the issue raised again, and so for the most part I complied with the ban. Besides, it was impossible to get mephedrone anywhere; and for the kind of bingeing I needed it for, MDMA was out of my price range. But since Colette was away, and since I was actually going out, I thought I might as well have a few pills. Colette had let me have the keys to her apartment for the weekend, but I did not want to go back there, where I might disturb the disagreeable couple sub-letting the other room for the summer. I had six hours to kill. I trekked out to the Irish Museum of Modern Art, but it was closed, so I went to a pub to read. Six hours later, when I met Ross at Vicar Street, I was very drunk. I asked him what he was having and he said he was not drinking. I asked him if he minded me taking pills. I remember that he said no problem and I remember that we stood very far from the stage, but the next thing I recall, we are back in Colette's apartment, eating chips on Colette's bed, listening to music on her laptop, and I am conscious I still have some pills. After telling Ross he can sleep in Colette's bed, I say goodnight and head to the sitting room with the laptop in hand. My skin feels grubby from alcohol withdrawal, but there is no booze in the fridge, so I swallow a single Valium instead. I crush three dodgy pills into twelve dodgy lines. I snort two and, feeling a wave of nostalgia for the pain in my nose, I ease the plate under the couch and open up an Incognito window. Browsing the Most Popular section, I load up some films I have been failing to watch unbroken since mephedrone was banned. With a cold hand I

take my dick from my pyjamas and wank it as patiently as I used to, but sleep sets in like a punch in the back. Suddenly it is light outside. The laptop is open, my dick in my grasp. I tiptoe through the flat, but there is no one around. When did Ross leave? How long was I out?

O O O

While the train was stopped at Hønefoss, the angle of the camera changed, adjusted upward about ten degrees: evidently it had been slumping a bit. From this new angle, I had a clearer sense of Oslo getting nearer. What did I know about Oslo? Nothing really, except that it had once been called Kristiania and was the setting of Knut Hamsun's *Hunger*, a novel for which darkness is a substance with metaphysical, almost magical qualities, casting light on those parts of our selves which lie hidden. The same is true of Stig Saeterbakken's *Through the Night*, a bleak novel in the tradition of Hamsun, in which the narrator unconsciously misdirects the reader for several hundred pages, repressing an important piece of information right until the closing pages, when at last he finds the room that he has travelled several hundreds of miles by train to find: a special, spectral room in which, as 'the blackness of the eternal night' closes in around him, the narrator sinks further down into the couch, down into the depths of his own unconscious mind. Standing up, he smashes his head against the wall. Feeling only numbness, he continues.

O O O

Had anybody seen my slumberous hand gripped round my flaccid cock? It was not a question I could answer with any certainty. Maybe Ross had, but Ross wouldn't tell. What about Colette's flatmates? I went home to my family for a week and tried my best not to think about it, but in the evenings, when Colette and I talked on the phone as she walked home up Camden Street after work, I was always waiting for some word of the incident. By Friday I sensed I was in the clear. I stayed over for the weekend, on into Tuesday, then went back home. On Wednesday evening, Colette phoned. She said something strange had happened. Underneath the couch in her apartment, totally unconcealed, she told me, there was a hardcore porno magazine. A hardcore porno magazine? That's odd, I said, trying to sound completely unfazed. Colette said it must be that strange couple. In her voice I heard something like revulsion. I began to speculate. Maybe, I said, one flatmate had got out of bed to jerk off. Maybe they heard the other one coming and, after concealing the magazine, pretended to be returning from the bathroom. Maybe they went back to bed and just forgot it was there. I didn't sleep that night, or the night after, for fear that the magazine was some kind of sign directed at me, the non-rent-paying part-time tenant who had fallen asleep with his hand clasped round his own dick in the darkness of the sitting room. The following night Colette reported that the magazine was now on the coffee table. Why the fuck, she wondered, are they leaving this shit around? Once more I began to speculate. Maybe the magazine had been discovered by the partner of the owner. Maybe the owner had blamed me. Maybe this was them calling me out. Maybe. When she called the following night, she said the magazine had still been there when

before he and his suitcase arrived at the car park. For what reason had he checked his watch? What had he learned from the notice?

○ ○ ○

I had more or less stopped taking drugs a couple of months before Colette and I moved to South Korea, and I had more or less stopped watching porn once we got there. We were living in a small studio apartment now, in a country where internet porn was censored and difficult to access. I did not like my job as an English teacher, but in Korea life was easy. One Friday night in the kitchenette, the window was open, the air outside was hot, and Colette and I were drinking together, spirits were high, we were listening to Grimes, it was the weekend and maybe we were going out later. The conversation had a greater sense of openness to it than any I could recall for some years. We were talking about what had quickly become the old days: on one occasion a couple of years before, Colette told me, she had taken mephedrone on her own in her room and had been so scared at having done so that before going to sleep, she had flushed the rest of the bag down the toilet, resolving never to take it again. She said that she was happy mephedrone had been banned, that she could not trust herself around it, and that she was sorry for not explaining this to me at the time. I smiled and told her no problem, that I understood, that actually I had also taken it on my own a couple of times. Peering over her glass of Soju and Coca-Cola, she raised a knowing eyebrow. The fridge was humming. 'Oh,' she said, faintly smirking as she placed her glass on the table. 'I can just imagine.' She made no further enquiry. She might have said she didn't want to know.

[Square Brackets]

As they go on talking, we continue to see Nana and Paul mainly from behind. Paul has stopped pleading and being rancorous. He tells Nana of the droll theme his father, a schoolteacher, received from one of his pupils on an assigned topic, The Chicken. 'The chicken has an inside and an outside,' wrote the little girl. 'Remove the outside and you find the inside. Remove the inside, and you find the soul.' On these words, the image dissolves and the episode ends.

— Susan Sontag. *'Godard's Vivre sa vie'.*

Many 19th C. arts are leading towards cinema: the family photo album; the wax museum; the camera obscura; the novel[1]

In her introduction to the selection of Roland Barthes's essays that she and her friend Richard Howard stewarded into English translation following his untimely death in 1980, Susan Sontag noted that, with a symmetry befitting his classical sensibility, Barthes's body of work had begun and had fallen silent on the same subject: 'that exemplary instrument in the career of consciousness – the writer's journal'. It was a subject he returned to frequently. In a still untranslated 1966 review of Alain Girard's sociology of *le journal intime* (not a major essay, but one that Sontag would certainly have known) Barthes lays out what Girard sees as the three major historical periods of the genre: (i) from 1800 to 1860: authors and intellectuals keep a journal for themselves, with no thought towards future publication; (ii) from 1860 to 1910: the first journals to be published (Stendhal, Delacroix, Joubert) cause the proliferation of the genre; now journals are kept with the expectation that they might be published at some point, albeit after their author's death; (iii) from 1910 to the present day: the genre explodes, as writers and intellectuals start to publish their journals in collected volumes while still living. Writing three years after Alain Robbe-Grillet's *Towards a New Novel*, Barthes goes on to argue that, with the avant-garde's 'turn towards the object', the *journal intime* had entered a period of decline. 'As usual,' he writes, 'it was at precisely the moment when the genre became accepted by

[1] Susan Sontag. *As Consciousness Is Harnessed To Flesh: Diaries 1955–65.*

the public that it entered a crisis among creators.' And yet it was for neither moral nor aesthetic reasons, he postulates, that writers had ceased to speak in this first person – but because the 'I' no longer recognised itself as a stable and singular entity. Conceived as the purest expression of subjectivity, the *journal intime* had become a decadent form – codified, constructed, incompatible with the age.

Dreamt last night
of a beautiful,
mature David of
about eight years,
to whom I talked,
eloquently and
indiscreetly, about
my own emotional
stalemates as
Mother used to
talk to me – when
I was nine, ten,
eleven . . . He was
so sympathetic
and I felt great
peace in
explaining
myself to him.[2]

[2] Susan Sontag. *Reborn: Early Diaries 1947–1963*.

For the story of the chicken, of course, is the story of Nana[3]

Susan Sontag had been keeping a journal for four years when, on 21 November 1950, at the age of seventeen, she made what would be the unusually early penultimate entry of the year, in a notebook she'd opened the previous winter with a bullet-point account of a visit she and two friends had paid, in secret, to the Los Angeles home of Thomas and Katia Mann, whose phone number they had looked up in the directory. Eleven months on, an undergraduate in Chicago, Sontag opens this penultimate journal entry with a brief and broadly favourable appraisal of *Don Giovanni* at the City Centre Theatre, before moving on to more exciting news, namely the offer to do some research work with a distinguished sociology professor. 'At last the chance to really involve myself in one area with competent guidance.' Within ten days of meeting, Sontag would be married to this man, Philip Rieff. Nearly two years later, their only child was born: David Rieff, Sontag's future editor at Farrar, Strauss & Giroux. Responsible for stewarding her journals into print following her death, Rieff expresses doubts about their publication in his preface. She never published so much as a line of them in her lifetime. She never read from them to anyone. She spoke about them seldom. Those close to her knew of her practice, after filling a notebook, of 'placing it alongside its predecessors in the walk-in closet in her bedroom, near other treasured but somehow essentially private possessions'. As a person regularly represented in the journal, Rieff's editorial voice – in italics, between square

[3] Susan Sontag. 'Godard's *Vivre sa vie*'.

brackets – is a rich and complex textual presence: less Nabokov's Brian Boyd than John Shade's Kinbote. For the most part Rieff cuts in to impart objective facts, like the surname of a first name given. His voice is clipped and objective, even cold. Yet it is hard, especially when it speaks at length, not to project emotion onto it. It is a voice that invites us – as its mother said of photographs – to speculation, deduction and fantasy. One day in 1955, Sontag relays her collaborator's first words. It is a voice that snaps in two.

'How do people
have two
husbands?
When one dies?'
I answered:
'That's right. If
one dies, you
can marry again
if you want.' To
which he
answered: 'Well
then, when
Daddy dies I'll
marry you.' I
was so startled
and delighted
that I could only
reply: 'That's the
nicest thing you
ever said to me,
David.'[4]

[4] Susan Sontag. *Reborn: Early Diaries.*

The doubling of the self in dreams.
The doubling of the self in art.[5]

Susan Sontag was preparing her long and influential essay on the philosophical underpinnings of American art's move into silence, when, in June 1966, she made a short note about Hermann Broch's *Death of Virgil*: 'the nocturnal anguish that impels the creator, on his deathbed, to destroy his work'. Published the following year in *Styles of Radical Will*, 'The Aesthetics of Silence' traced a prestigious artistic lineage for the practice of Jasper Johns and John Cage, whose interest in silence she links not only to the renunciations of Rimbaud, Wittgenstein and Duchamp; but also Keats, Nietzsche, Bergman; Beckett and Stein (in whose fiction is discernible 'the subliminal idea that it might be possible to out-talk language, to talk oneself into silence'). Nowhere does she find a place for Hermann Broch, however, who in his portrait of Virgil's last hours imagines the poet deciding to burn his *Aeneid* in anger at the emperor. Nor, for that matter, does she address Kafka's instruction to his friend and executor, Max Brod, for all of his papers to be destroyed upon his death. That Sontag should never mention this unfulfilled instruction – not in this work, or in any work or journal entry ever – is notable. Indeed, in light of the ambiguity of her own instruction regarding her diaries, this silence seems conspicuous, deliberate. The sole conversation David Rieff ever had with her about them, he says in the preface to *Reborn*, took place after she was diagnosed with cancer for a third time, 'and it consisted of a single whispered sentence: "You know where the diaries are."'

[5] Susan Sontag. *As Consciousness Is Harnessed to Flesh.*

Concerning the
death of
Gertrude Stein:
she came out of
a deep coma to
ask her
companion Alice
Toklas, 'Alice,
Alice, what is
the answer?'
Her companion
replied, 'There
is no answer.'
Gertrude Stein
continued,
'Well, then,
what is the
question' and
fell back dead.[6]

[6] Susan Sontag. *Reborn: Early Diaries.*

How does one know one's own feelings?
I don't think I know any of mine now.[7]

Susan Sontag had been married to Philip Rieff for seven years when, in 1952, still only twenty-four years old, she enrolled as a postgraduate student in Europe – first at Oxford, then in Paris – as a way of getting free of him. In the ten years she stayed in Paris, Sontag's journals show her perfecting her French, pursuing intense romantic relationships (with Harriet Sohmers and the playwright Maria Inez Fornes), fighting for custody of her son, and immersing herself in the history of European cinema. In an undated 1964 entry listing 'films which quote other films', Sontag refers to Jean-Luc Godard's *Vivre sa vie*. Told in twelve chapters, the film had come out two years previously and starred Anna Karina as Nana, a young woman who, after leaving her husband and her son to pursue an acting career, turns to sex work and is eventually killed in a gun battle between two pimps. Published in her acclaimed first collection, Sontag's essay on *Vivre sa vie* (written the same year as her diary entry) extols Godard for his use of 'texts' within the narrative (Paul's story of the chicken; Nana's letter of application to the madam of a brothel; excerpts from Carl Dreyer's *Jeanne d'Arc*) to establish what the film wants to say. For Sontag, Godard was the first director to grasp that cinema could not deal seriously with ideas – could not represent ideas with any 'suppleness' or 'complexity' – without the creation of new film language to express them. 'The film eschews all psychology; there is no probing of states of feeling, of inner anguish,' writes Sontag impassively. 'We don't know Nana's motives except at a distance.'

[7] Susan Sontag. *Reborn: Early Diaries.*

This time for
writing to
entertain other
people is over. I
don't write to
entertain others, or
myself. This book
is an instrument, a
tool – and it must
be hard + shaped
like a tool, long,
thick, and blunt.
This notebook is
not a diary. It is
not an aid to
memory, so that I
can remember that
on such and such a
date I saw a film of
Buñuel, or how
unhappy I was over J,
or that C—
seemed beautiful
but Madrid not.

[Text][8]

[8] Susan Sontag. *Reborn: Early Diaries*.

The emperor – it is said – sent to you, the one apart, the wretched subject, the tiny shadow that fled far, far from the imperial sun, precisely to you he sent a message from his deathbed. He bade the messenger kneel by his bed, and whispered the message in his ear. So greatly did he cherish it that he had him repeat it into his ear. With a nod of his head he confirmed the accuracy of the messenger's words. And before the entire spectatorship of his death – all obstructing walls have been torn down and the great figures of the empire stand in a ring upon the broad, soaring exterior stairways – before all these he dispatched the messenger. The messenger set out at once; a strong, an indefatigable man; thrusting forward now this arm, now the other, he cleared a path through the crowd; every time he meets resistance he points to his breast, which bears the sign of the sun; and he moves forward easily, like no other. But the crowds are so vast; their dwellings know no bounds. If open country stretched before him, how he would fly, and indeed you might soon hear the magnificent knocking of his fists on your door. But instead, how uselessly he toils; he is still forcing his way through the chambers of the innermost palace; never will he overcome them; and were he to succeed at this, nothing would be gained: he would have to fight his way down the steps; and were he to succeed at this, nothing would be gained: he would have to cross the courtyard and, after the courtyard, the second enclosing outer palace, and again stairways and courtyards, and again a palace, and so on through thousands of years; and if he were to burst out at last through the outermost gate – but it can never, never happen – before him still lies the royal capital, the middle of the world, piled high in its sediment. Nobody reaches through here,

Two Canadian
doctors report
making a skin
graft on a
woman patient
of skin donated
by one of the
doctors –
after several
sessions of
hypnosis
in which the
woman was
told the graft
mould would
definitely take.[10]

[10] Susan Sontag. *As Consciousness Is Harnessed to Flesh.*

I feel like Kafka, I said to D.[11]

'Conversations take the importance, the seriousness, the truth out of everything I think,' writes Franz Kafka in a 1913 journal entry that Susan Sontag read aloud to her son in the summer of 1975, before her first, gruelling battle with cancer had been won. Thirty years later, the whisper to Rieff gives the Brod he should be: his preface tells of strong temptations to burn the diaries, to destroy them and the self she had constructed across them; then finally, he concedes, *pure fantasy*. 'The reality is the physical diaries do not belong to me.' Three years before her death, Sontag sold her papers to UCLA for a record $1.1 million, agreeing that access become more or less unrestricted five years after her death. 'I soon came to feel that the decision had been made for me,' says Rieff, who didn't burn them.

[11] Susan Sontag. *Reborn: Early Diaries.*

[Unfamiliar Angles]

I have dreamed of my film making itself as it goes along under my gaze, like a painter's eternally fresh canvas.

— Robert Bresson. *Notes on the Cinematograph* (trans. Jonathan Griffin).

In the summer of 2007 I lived with two friends, Brian and Conor, in a second-floor apartment close to Père Lachaise Cemetery in Paris. At first we spoke in French, then in English, next in whispers, and finally not much at all. Perhaps if Brian had got his own room things would have worked out better. But he didn't. We figured two bedrooms would be enough. An old couple met us on Rue Saint-Maur and let us into the apartment. We handed over enough cash to cover two months of rent plus the deposit and they presented us with two sets of keys plus a bottle of Chopin vodka. After they left, we drank the elegant vodka straight and pretended it wasn't just as disgusting as normal vodka. The day caught up with us. I slept where I fell but took care to fall precisely. I took the master bedroom, Conor took the corner bedroom. That was that. I don't think it ever occurred to me to feel sorry for Brian, folding his bed out from the couch every night, folding it back in every morning. We were in the same class, had made the same friends. I liked him but we weren't close. He had read books I had not yet even pretended to have read, and all he seemed to see in most of them was error, bad faith and banality. At Dublin Airport he had been required to pay a considerable surcharge even after the embarrassing spectacle of him reshelving Michel Foucault's *Dits et écrits*: tome 1 (1.23 kg) in my bag, and tome 2 (1.25 kg) in Conor's.

○ ○ ○

One night not long after we arrived, I asked Brian and Conor when their birthdays fell. Conor hesitated. He was about to embarrass us. 'Today,' he said finally. He had turned nineteen unannounced,

almost. I would have felt bad for not giving him a gift if I weren't so taken with his reticence. Conor, I realise now, was not fashionable, but he carried himself in such a way that I presumed he was. Even still, I remember being surprised at the ease with which he was able, on one of our first nights out in Paris, to hook up with another guy. We were not in a gay bar, it didn't seem like he'd made a particularly concerted effort, and yet there he was on the other side of the dancefloor, all set. When later that evening I told Brian I was heading back to Rue Saint-Maur, he said perhaps we should wait around for Conor. I think I frowned: Really? He looked back across the room; after a pause, he said he supposed not. On the walk home, for the sake of saying something, I said the guy Conor had hooked up with looked a lot like the footballer Tony Adams. I don't know if he knew who Tony Adams was or what he looked like, and as I recall him now, the guy looked nothing like Tony Adams, but Brian seemed pleased by this remark.

○ ○ ○

During the day we mostly sat around reading whatever books we'd brought or bought, but often we just read newspapers. I got through more newspapers in Paris than I ever had before or would again. It was something to do as a group. Together we would take a red pen to the work of a particular *Irish Times* literary critic, underlining what we perceived as errors of grammar, judgement and tone. Together we would scoff at the half-understood but no doubt bloated rhetoric of *L'Humanité*. Together we would fail to identify a single correct answer to the crossword in *Le Monde*. Bliss

was it in that dawn to be alive. Sometimes at night we would go to a bar down the road and sometimes Conor and Brian would go to a gay bar instead. Occasionally I would join them, but usually I'd stay home. On such nights, I would inevitably get drunk alone, jerk off to a copy of French *Playboy* I'd bought in a kiosk several streets from our apartment, then sit by the window in silence. During the day Conor spent a lot of time sitting in the same place; I used to look at him looking and wonder what he was looking at. There was nothing much to see at night in any case. Once in an email I told my girlfriend, Sarah, who was spending the summer in Montreal, which by her accounts seemed far more eventful than Paris, that I had seen two guys break into a car and drive away.

○　○　○

After two weeks of living in Paris the most complex thing I'd told a French person was what I did not want in my sandwich. We were growing restless. At the launderette Conor asked an old woman if there was a cinema nearby. Her gaze fell just beyond us, stayed there. A row of industrial dryers spun one way and then another. *'Autrefois'* was all she said.

○　○　○

I can't remember who saw the notice in the back of *L'Humanité* advertising a get-together hosted by the youth wing of the French Communist Party, nor can I picture the moment when the tone in the room turned from one of derision to suggestion, but I know that

at around five o'clock the next evening all three of us set out in the direction of the French Communist Party's headquarters. Despite our collective struggle to bring 3,474 pages of untranslated Foucault on what was essentially a holiday, none of us at the time could lay much claim to political radicalism. Walking a little nervously from the eleventh arrondissement to the nineteenth, we attempted to construct three consistent, properly sourced political backstories, as if making our way not to a social event but to our own show trial. We needn't have bothered, of course. When we got there, it seemed that our willingness to socialise with members of the French Communist Party, to sign the petitions of the French Communist Party, to ourselves become members of the French Communist Party, was enough to convince all involved that we were broadly speaking sympathetic to the French Communist Party. In a room which I now remember as closely resembling a GAA disco, there was a lot of quiche and a little dancing. Conversation, such as it was, focused mainly on the politics of everyone's parents, which tended to be one of two things: strongly pro-Communist, or strongly anti-Communist. Before we left we agreed to celebrate Bastille Day cooking crêpes in a French Communist Party truck in a *banlieue défavorisée*. I tried to make a joke about how my strongly anti-Communist parents would really hate this plan, but I don't think anyone was listening.

○　○　○

On the way home, we passed the hostel on Rue La Fayette where a few months before, on a midweek break during which everyone contracted food poisoning and someone lost their passport, the

until then been a very slender sexual history. Certain of its images seem now too cinematic to have happened as I remember them. The bluish charge of moonlight on our bodies. The silhouette of his head working up and down the silhouette of my dick. The slight sway of half-closed curtain just beyond us. There is no reason to distrust these images more than any other – the window undoubtedly *was* open, often the light *did* fall like that – except that the tone they evoke seems so much at odds with what I remember against my skin. I remember that kissing Conor's stubble felt like kissing my own father. I remember being thrown by the unfamiliar angle of his dick as I wanked it. I remember that when he put his dick in my asshole, it hurt and kept hurting. Either I told him to take it out after a few minutes or he sensed I wanted it taken out. I know I was embarrassed and even a little ashamed at this, but mostly I was disappointed that what I'd wanted did not seem, for the moment at least, physically possible. I started to suck his dick as a matter of urgency; and when finally he came on my face and my hair, we both laughed.

○　○　○

Until then, I had never thought about gay sex with anything other than a vague squeamishness I knew to say nothing about. I don't remember it clearly, but in the days that followed I was probably somewhat troubled by the idea that I could be gay. Yet there was at the same time a part of me that found the idea of what had happened not a little glamorous. The next day Conor looked up from whatever he was reading by the window. He told me that his asshole had been sore for a few days the first time he had taken it.

He told me that if mine was still sore it would not stay that way forever. We both smiled, continued reading. There was about Conor's remarks an insouciance which I liked to believe I had overnight acquired as well. Around Conor, perhaps I had. Our interactions did not become newly charged or strained; our relationship continued much as it had before. I was at ease. At least that's how I remember it. The written evidence tends to suggest otherwise. The written evidence tends to suggest a mood of uncertainty and panic. Partly out of guilt, but mostly as a misguided attempt to cover my back if things ever got out, I sent emails to Sarah in which I said that Conor, with whom she too was good friends, had made and continued to make advances on me, despite the offence I claimed to have taken. In fact the opposite was true. I had taken Conor's hand. I had made a move. I wanted him. I sent emails every day, in any case, from an internet cafe up the street. These comprise a litany of lies, exaggerations, belittling remarks about the person I was writing to, and unwarranted insults about her friends, my friends, pretty much anyone I came into contact with. I complained about the behaviour of the homeless people on Rue Saint-Maur. I complained about the act of lying. The references to Conor were tinged with a level of homophobic innuendo I would have righteously condemned in others. I intended to have them printed and bound, as a gift. There are no redeeming features in it.

O O O

Conor and Brian were by this point not speaking to each other. All communication passed through me, and I would filter it in

whatever way I felt was least likely to result in Sarah finding out I'd slept with Conor. At times I spread deliberate misinformation. In Brian's company I acted as though nothing had happened. I remember one day we talked at length, longer it now seems than we had ever talked alone before, about Racine, about *Madame Bovary*, about a short story he was writing in which three figures had become involved, I think, in a love triangle. Oddly, it did not occur to me at the time that he could be writing about our own situation, and so I am not sure what to make of this final detail. Either it is an invention of memory, or the summer of 2007 had become one in which I was no longer capable of recognising myself in even the shallowest of subtexts. Needless to say, we did not celebrate Bastille Day with the French Communist Party.

○ ○ ○

When I remember it now, it is always a night scene. Some of Conor's friends had arrived in Paris, some of whom had other friends still. We were practically a milieu. We all went out to a restaurant, or maybe just to a bar, and I complained to an attractive English woman with a managerial role in Shakespeare & Co. about the state of her bookshop's essay section. I'm not sure if she was supposed to be impressed by this; anyway, she wasn't. Next time only Conor was invited. He became involved with a French guy called Thomas. Some nights he would come home, some nights he would not. I do not know if Brian believed I was asleep when late at night, with Conor still out, he would pace our ill-lit apartment, attempting to sing the deepest, most guttural parts of *Parsifal*, a recording of which had come free with a weekend edition

of *Le Monde*. The story of *Parsifal* was not one I was familiar with, but there was about his singing a sadness I found almost unbearably moving. It was as though all the force of his lonely erudition had found subtle expression in that otherwise disgusting sound. From my room I coughed as hard as I could, hoping he would stop.

O O O

At around this time I began to buy new clothes; smaller, darker clothes. As I made my way to town one afternoon dressed all in black, wearing a pair of sunglasses I'd found in the apartment, tilting my head in such a way as to give the impression that I was critically appraising the city's architecture, attempting to make eye contact, such as it was given the sunglasses, with pretty American tourists at Notre-Dame, before calling in at last to Shakespeare & Co., where still I did not remove the sunglasses, I felt like Lou Reed. The manager was ordering stock; remembering my criticism, she asked what essayists I thought the shop so badly needed. I looked at their essay section for some time. I did not know the name of a single essayist not already represented on the tiny shelf. No sooner had I become conscious of how ridiculous I must have looked wearing sunglasses inside than I realised I was no longer in a position to take them off. 'Let me give that some thought,' I said. Thoughtfully I strolled around the shop for a minute or two, moving up and down the fiction shelves but failing to identify even one novelist I was sure wrote essays too. I returned to the till, having no alternative. 'What you need', I said finally, as if coming at the issue quite inventively, 'is other books by the same essayists.'

o o o

One day on a metro near Opéra I realised I was sitting opposite Thomas. I could see he wasn't sure how he recognised me and it was a while before one of us finally said hello. The air grew heavier then. Neither of us could think of anything to say. I noticed that he had nice hair so I asked where he usually got his hair cut. He smiled, he might even have blushed, but he would not tell me.

o o o

The next time Conor was naked in my bed, it was partly Brian's doing. A mutual friend, Annie, had come to stay for a few days. Brian was very close to Annie and her visit meant a lot to him. He was insistent that Annie be given her own room; Conor would have to sleep in my room. It did not happen as a matter of course. I turned the lights off and we lay there a while doing nothing, whispering about this or that, perhaps half waiting for Brian to fall asleep in the other room. Yet from the moment one of us stirred, things unfolded in a manner I remember as more or less indistinct from the first time. I sucked his dick, he sucked my dick. Once again I had trouble relaxing. At some point I heard Brian at the door. Conor told him to fuck off. But panicked, I got up and put my pants on. Leaving Conor in my bed, I walked into the front room, lay down in Brian's pullout bed and, partly because I figured he would sympathise and partly because I thought it would cause him to become attracted and thus beholden to me, I pretended to become very distressed, managed almost to cry, about what I said I now knew was the reality

of my homosexuality. He said that he would say nothing. I said that I was very grateful to him. I did not say that I wished him dead.

○ ○ ○

When later, to one close friend or another, I began to reveal what had happened in Paris as yet another exotic facet of my fascinatingly complex personality, I would always lie about this second night. I would say that since Conor fucked me the first night, I fucked him the second night. In fact I'm no longer sure we fucked at all the second time, but if we did I'd have taken it. I knew that Conor did not like to be fucked, and although I suppose I'd have liked to fuck him at some point, I think I'd have preferred to learn to take pleasure in being fucked by him. Yet, on a level I was not entirely conscious of, it made me uncomfortable to think that my role had been only to be penetrated. It seemed to homosexualise me – to feminise me – to a degree that the story I'd come to tell myself about myself could not accommodate. I was unable to position myself as the object of homosexual penetration within a narrative in which I would try everything once, unless I convinced myself that at some point I had been its subject too.

○ ○ ○

The domestic situation grew predictably worse, my emails to Sarah more outlandish. I found it difficult to sleep at night. Eventually I booked a flight home; I would leave in two weeks' time, earlier than the others. It was not until these last days of

summer, when I would disappear from the apartment on my own, walking with no intention but to tire myself out, that I began to get a sense of how little I had come to know the city. I was not even certain, for instance, which side was the Right Bank and which was the Left Bank, though naturally this had not prevented me from telling Sarah several weeks previously about the small independent 'Left Bank' cinema we'd found. There, in happier times, all three of us had paid to see a documentary about Jacques Vergès, a celebrated defence lawyer for alleged terrorists and war criminals. The room was empty except for us and, a few rows ahead to our right, a thinly coiffed old man with dark sunglasses on. If you tilted your head to the correct angle, it was possible to see the distorted reflection of the film's images in the convexities of the old man's shades. It was not, as far as I could understand, a humorous film, but he chuckled softly throughout nonetheless.

○ ○ ○

The night before I left, I was still awake when Conor arrived home from wherever he'd been out. He knocked on my door: *C'est moi.* I told him to come in. He did not seem at all drunk as he began taking off his clothes. He stripped down to his boxer shorts, and then no more. He got into bed. I could feel that he was hard and so was I, but together we just lay there, at rest, not sleeping, not saying much at all. Occasionally one would tighten our hold on the other, then it would fall loose again. In my room we lay like that for a very long time. Light crept through the curtains and I remembered a few days before, when Conor had been sitting beside

the window in the living room as he often did, and this time I had asked what he was looking at. He did not answer immediately, and when he did it was a question. He asked if I could feel a sense of anticipated nostalgia for the view. I looked out at the street and the supermarket and the purplish glow of evening and the car I had not seen stolen. I said I did not understand the question.

II : IMAGE

[Closer Still]

My hand

[. . .]

was not at all my everyday hand;
it moved like an actor – indeed, I
might say it observed itself,
exaggerated though that sounds.

— Rainer Maria Rilke. *The Notebook of Malte Laurids Brigge* (trans. Burton Pike).

— André Kertész. *Elizabeth and I, 1933.*

An elusive character about whom little tends to be said except that he was quiet, uxorious and reserved, André Kertész usually recoiled whenever he was labelled a Surrealist. *Je ne suis pas surréaliste*, the Hungarian photographer would say. *Je suis complètement réaliste.* For a short time after moving to Paris in 1925, Kertész had been distantly acquainted with Man Ray, yet he always considered the American's experiments in photography something of a joke. Drawing on the negative; solarising the negative; abandoning the camera altogether in the production of his Rayographs: none of this carry-on accorded with Kertész's conception of what photography ought to be. So, given this value he seemed to place on the ontological integrity of the photograph, it has always been interesting to me – it has always seemed a bit surprising – that Kertész had no reservations about interfering with his images after they'd been printed. *With a jeweller's precision*, says the critic Annie-Laure Wanaverbecq, the quiet man cropped and cropped, mostly trimming the edges to perfect the composition, but sometimes to exclude an extraneous, or unwanted, detail. Not for him the puritanical geometries of his friend Henri Cartier-Bresson: Kertész did not view cropping as a point of dishonour, much less of failure, but as an invitation to look again, to shift the meaning of an image by refining its means.

It might be she didn't want to appear triumphalist in the face of her family's opposition to the marriage. It might be she just wasn't feeling it that day. Two years had passed since she left her family, her homeland, her language, her entire social structure, and now her name had been forsaken too: it would not be surprising to find she'd come to harbour some resentment towards her husband, especially given that at some point between their fateful reunion in Hungary in the winter of 1930 and their settling down together on Rue de Contentin near Montparnasse in 1932, Elizabeth discovered that her unofficial fiancé, for whom she had risked everything, had married someone else in secret. The date varies depending on the source, as does the spelling of his first wife's name, but what's clear is that on some date between January 1927 and October 1928, André Kertész married a photographer and violinist named Rozsa or Rozsi Klein, a fellow Hungarian *émigrée* who'd lived in the hotel where Kertész had stayed in his first years in the city. Erzsébet's letters had dried up, it seems, and he had come to believe that their relationship of eight years was over. It had taken him so long to establish himself in Paris that, with no word from her for months, maybe years, he figured Erzsébet had grown tired of waiting and married someone else. To biographers, Kertész always refused to talk about his first marriage, cropping Klein from his life-story as though an extraneous detail, obliterating any trace of her he could. If the marriage is ever mentioned, it is usually described as *born of emotional need and loneliness*; often it's described as *short-lived*. But it was not until after Erzsébet's arrival in Paris – a full year after he had discovered, on his return trip to Hungary, that she had been sending him letters all along, albeit to the wrong

Sitting for a photograph in the 1930s, one was required to remain still for approximately three seconds while the negative became exposed. Movement made the image come out blurred, faintly transparent. Having modelled for Kertész since around 1919, Elizabeth would have been aware of this requirement as she sat down on the divan in the summer of 1933 and waited for her new husband to get the timer set up. Now he sits down and puts his arm around her. She hears the camera click and suddenly she becomes conscious of the ticking of the tiny watch she wears on her left arm. Her husband's not a bad guy, she thinks, softening at the edge of the first second. *Tick.* At heart she knows he's done nothing wrong, nothing unforgivable. Her letters *had* stopped arriving, she tells herself again, so she can see how it had *seemed* like they were through, and in this city where he still can't speak the language, it's easy for her to imagine how lonely André was, how vulnerable he must have felt, how lost. Another second pulses through her arm. *Tick.* Still, though, could the fucker not have checked? Could he not have made some effort to find out where I had gone? If he really loved me, would he not have tried to win me back? He need not even have come home, she thinks (as she has often thought before). Could he not have asked his brother to enquire? *Tick.* How tainted this day feels, she thinks. A sinking thought: fourteen years in love and here she is, his second wife. I wish he wouldn't stare at me like that, she stews. So close to me, so needling, so – *Andor, please, can't you see I'm not enjoying this?* At some point in these three seconds, Elizabeth moves her left hand. Not her face, not her legs. It is her left hand that she moves: for those fingers come out blurred, and that wedding ring is doubled.

In 1927, two years after he'd moved to Paris, André Kertész sent Erzsébet Salamon a photographic postcard entitled *Self-portrait in Darkroom*. From a side angle, the picture shows the photographer at work, a lonely soul in a three-piece suit, standing with his head faintly bowed above a tray of photos he's developing. I don't know enough about the minutiae of Kertész's working practices to tell you whether or not he was still using the same darkroom in 1933, but that's precisely where I imagine him anyway, head at the same angle, suit of the same thread, as he brings *Elizabeth and I* closer to his face. It is not good. Not only does Elizabeth look less than thrilled to be there, but there's a minor imperfection to the left of the frame, a small but certain blur which has caused her wedding ring to appear doubled. He wonders was she nervous, or did her hand just slip? It had been many years since Elizabeth had posed for him so formally. Is it possible she *forgot* to stay still? Hardly. There in the darkroom, André stands with his head bowed deeper now, taking some time to collect his thoughts. Not long passes before it occurs to him: no, he thinks, surely not, did she move her hand intentionally? He wonders. He wonders would she really? Would she sabotage her wedding photo? To get a dig in? Well, the joke's on her. Some time in 1933, Kertész would develop the negative twice more. This may have been a matter of weeks after first developing it. It may even have been a matter of months. Yet I find it somewhat difficult to imagine it was not a matter of minutes after he first noticed the imperfection that Kertész is pegging two newly exposed sheets to the darkroom string. Then he takes a seat. As he waits for the image to appear again, he wonders if Elizabeth will ask to see the photo later. He decides that if she does, he will not watch her face.

darling

I have tried to fix you[12]

Over the course of two croppings, Kertész will slice right through his wife's arms and chest, her shoulder, throat and face. Unlike many of the croppings in his oeuvre, neither of these new images has been graced with a title to distinguish it from the original shot. There is no hierarchy of images here, no sense of either work as a mere detail (*detailler*, to cut up into pieces); each is presented as a work unto itself, an autonomous whole with no less claim to the title than the originary photograph. But this is cropping we're talking about, cropping which is essentially an art of exclusion, so let's ignore the implied dictum of each title and first consider what is absent here. In neither image (which henceforth I'll refer to as 'Portrait' and 'Landscape', according to their page orientation) do we see anything below the neckline of either sitter. Once crossed so portentously away from her husband, Elizabeth's legs have been cut off in each. The inward of her arms is lost. The imperfection has vanished. Amputated as if in punishment for what took place in time to the ticking of her watch, her blurred hand has twice been consigned to the bin. Her body language has been muted, her doubling act cut off. Precious little of Elizabeth's ire has been kept in either image. Both of them are reticent to the point of telling lies.

[12] Saint Sister. 'Corpses'.

— André Kertész. *Elizabeth and I, 1933.*

Much the more orthodox of the two new images, 'Landscape' shows both sitters from the neckline up, its frame just large enough to accommodate their heads comfortably. André's gaze falls down on Elizabeth as devotedly as ever, while hers, out of context, appears to soften. Look at Elizabeth for long enough and it's just about possible to make out the first tremors of a smile taking shape beneath her blank expression. For all that this image takes from *Elizabeth and I*, 'Landscape' does not add much back, contributing next to nothing but a disingenuous reassertion of hegemonic ideas about the autonomy of the face. It looks quite like a traditional wedding photo. I guess they kept this one on the wall.

— André Kertész. *Elizabeth and I, 1933.*

'Portrait' quotes much less of the original photograph, and really skews what little it takes. It is the more disturbing frame. Not only has the blurred hand been severed, and the legs cut off once more, but a whole side of Elizabeth's face now gets the chop as well. Here is a bride with a bisected face: how happy she looks out of context! Between the top of her head and the top of the frame, a channel of space works to emphasise the trajectory of her gaze that looks up to the camera like a suppliant in prayer. What remains of her is half a nose, just over half a mouth and her right eye, the one with some glint in it, which now seems to soar with optimism. For the sake of the composition, Kertész has had to follow Van Gogh in cutting off his ear. But his eyes remain untouched. *Of course* his eyes remain untouched. It's these eyes we inhabit here. What these eyes do not see, the cropping hand cuts from the frame. 'Portrait' depicts what it enacts; enacts what it depicts. More starkly than anywhere in the series, it's his own male gaze that's doubled here.

— André Kertész. *Elizabeth and I, 1933* [1964]

A quarter of a century would pass before Kertész came back to *Elizabeth and I*. The year is 1964 and the pair have been living in New York for almost thirty years. With regular commissions from *Life, Vogue* and *Home & Garden*, Kertész brings in a salary of sorts, but for many years his wife has been the principal breadwinner, having co-founded a successful cosmetics company with Frank Tamas, her friend and partner, a man whom she's been spending a lot of time with lately, since he went blind. 'Elizabeth's affection for a man who was legally blind must have been particularly hurtful,' says biographer Kati Marton. Yet if '1964' is anything to go by, perhaps this blindness gave André pause. *Have I looked at her too much?* he asks. *Exactly how oppressive is my gaze?* When Kertész returns to *Elizabeth and I*, it's the *hors-cadre* that strikes him: such crude projections, so controlling, and not without a violent edge. He develops the negative again. He lays the print down on the table. He stands over it a while. He is seventy years old. How much does he remember of that day? Of that Elizabeth? One more time, he slices through her face, re-enacting a thirty-one-year-old gesture to the letter until, arriving with the blade at Elizabeth's neckline, he turns, in the spirit of her amputated leg, not *towards* his wife's husband, but *away* from him. This new work contains just one eye. Not his, but hers, looking straight into the camera, black and unglinting. It is Elizabeth's gaze we inhabit now. Of the man who took the photograph, we see nothing except – gripped menacingly to her shoulder, like an epaulette – a hand. That is the hand he has been slicing you up with. That is the touch of his gaze.

The Estate of André Kertész declined permission for the inclusion of this photograph.

[Veronica]

Define loneliness?

Yes.

It's what we can't do for each other.

What do we mean to each other?

What does a life mean?

Why are we here if not for each other?

— Claudia Rankine. *Don't Let Me Be Lonely*.

In the waiting room of the Department of Social Security, I read while you registered as a resident in the city I was due to leave when in September I would go back to do a Masters in Dublin. I figured I had enough money to do nothing until then. Teaching the previous year in South Korea, I'd saved over twice as much as her. I arrived in Munich with close to ten grand. That was much more money than I'd ever had before, but the hotel we'd booked to stay in till we found a flat was not as luxurious as its cost suggested or as the pictures on the website made it seem. Five, six storeys tall, it was located just behind the Hauptbahnhof, the city's central train station, on a road where a fat sloppy mohawk of week-old slush rolled up the centre of each lane, two parallel lines travelling from the bookies on the corner, passing our hotel, a cash-for-gold outlet, an entirely automated casino; and still no closer together or further apart when eventually they turned to an abysmal mush at the busy intersection of a long street lined with sex shops, adult-video shops, and twenty-four-hour strip clubs, outside which the city's loneliest men would stand, from morning to night, frankly observing the live broadcasts of the pole dancers available to watch inside, up close and in the flesh, if only they were willing or able to pay the price of admission. Some of these men looked so defeated. But others, like the short wiry few standing directly in front of the entranceways trying to steal a glance through some black slit of purple drapes, seemed graced or cursed by an infinite, infernal hope. Walking down that street disheartened you each morning. What sort of city was this which kept its central railway station in the middle of the red-light district? It was clear you felt differently about the whole thing, but I remember crunching through the snow towards the

How many little bags had Colette flushed down the toilet before those terrible days had ended? Every time she'd done so, I'd been furious. Yet as the sun came up in the wonderful flat which she had so promptly found in Rotkreuzplatz, a tidy little suburb with a square, within walking distance of the museums and the *Altstadt*, I was long reconciled to all the flushing. I was probably even thankful by now. You loved to sleep, you slept at any chance, but as soon as the alarm went off each morning in Munich, you had to get up and go to work while I stayed on in bed, not quite awake, not quite asleep; luxurious beneath the covers and only half aware, at most, of your movements as you left the shower, dried yourself, your hair, straightened your hair, ate breakfast and got dressed. I liked it when you got back into bed, whispering *ten minutes*, whispering *fifteen*. Then when I woke up again, woke fully, you were gone. Now I sort of wrote. Now I sort of read. Now I sort of tried to study German. Now I listened to football podcasts in the bath. Then I snooped hungrily around the flat. Because I had no job, nor any intention of getting one, the sub-let contract was in your name alone. We had only one set of keys. To the leaseholder, Lena, an artist in her early thirties who'd moved to Cologne for the year, I was for all intents and purposes invisible. She knew you had a partner, but not that I lived in Munich, still less in her apartment, which, five years previously, she had taken on in a state of long-term ruin, and refitted in her own style and image. (Or so you said she told you at the viewing, the one we figured I, as someone with no steady income, should not be present at.) Her paintings and photomontages, all marked by a disquieting ornithological motif, were tacked to every wall in place of wallpaper, lending an air of the

stage to our bedroom, bathroom and kitchen, at the end of which there was a tall narrow window, the most public in the flat, situated so close to the street that, even in daylight, it seemed somehow very distant. Did we ever do much looking out that window? No, not much that I recall. Anyone who passed while you were looking did so at such close range that no sooner had they come into view than they were gone, like that, unregistered but for the blurred sweep of a trailing scarf, the back of a winter coat. It was in the unheated room next to the kitchen that I spent so many hours alone: Lena's old studio, which she said we weren't supposed to use for anything except storage. Light filled that room like water in a tank. I'd never seen so much as a photograph of Lena, but through the plastic boxes of her stuff, stacked on icy monochrome tiles, I scavenged in search of I don't know what. She kept a lot of interesting things: objects picked up on trips to Canada, the United States, Mexico and Turkey, most of which seemed more than tourist souvenirs or imitations – antique binoculars and flower seeds, screws and musical scores, fur coats and fake revolvers. Not long after you left for work one morning, I walked barefoot across the tiles and set my cup of instant coffee down beside a box in which, beneath a pile of stuffed crows and a bunch of prematurely aged paperbacks by Thomas Bernhard, I came across a thick stack of sketchbooks – A3, A4, as small as A7 – the majority of which had been done in charcoal: usually of birds; but sometimes three-dimensional abstract structures. 'A drawing is essentially a private work,' Berger writes in *Permanent Red*. Did I linger over Lena's drawings a little longer than appropriate? In regarding these private shapes, in the intimate disorder of this room, itself proscribed, I felt, I suppose, some voyeuristic pleasure.

little to the architectural avant-garde. With the country's economy rapidly expanding, it had been necessary to rebuild the cities with haste. Some important temples, civic buildings and courtyards were reconstructed in the traditional Hanok style, but in Gwangju there were few clear traces of continuity with the pre-bombed city. Here was a mode of reconstruction which seemed mostly devoid of nostalgia, a provisional architecture, an architecture of emergency that had remained the dominant mode until the early nineties. To live and breathe in a space of such visual and spatial consistency felt strange. You recall it as a space without texture; a space given over to the sign; and for those of us who had already given up on learning Hangul, a space taken over by projection and fantasy. On the roof of a building not far from our flats stood a replica of the Statue of Liberty, one of many motels in the city, where it was possible to book a room for as little as an hour, if you wanted. South Korea was a culture – you would regularly assert, as if you knew anything about it – whose highly formalised codes of propriety were underscored by a becoming ease in pointing out those spaces where its codes could be transgressed in private. Once, near a motel in Busan, you and Paul had first discovered billiards. On the table were the traces of old games going who knows how far back. The balls, larger than in pool or snooker, were very satisfying to strike. Around midnight, we had finally left the hall, heading out to one of the BBQ restaurants that lined the same street, all framed by signs above the door with a cartoon depiction of the animal whose meat was served inside: pigs, crabs, cows, ducks. Anthropomorphic tongues licking anthropomorphic lips, you said to him, salivating in anticipation of eating their own flesh.

head. But didn't I feel European . . . I shook the key into the door and said hello before it opened. When you got inside, you smiled, began to comment on the smell. How nice the coffee made the kitchen air, you said, or were about to say before you spotted the large octagonal device on the countertop, and lifting it revealed a fresh, distinctly octagonal burn mark. It had been a long time since you last freaked out at me. In Korea, we'd hardly fought at all, though partly I suspected out of fear of being sad so far away from anyone we knew or trusted. I suppose things had been simmering away. You were pissed off about the amount of time I was spending in the flat. You never leave your pyjamas, she said. You always find a reason not to meet this group of people I've made friends with. You didn't like the look of them, it's true: that horde of rudderless expats, of various ages and nationalities, none of whom seemed to have anything in common except a kind of desperation in their cheery Facebook smiles. One must have a milieu and all that, but notwithstanding her anxiety about who she'd hang out with when you left, they all looked so far beneath you and me that I just couldn't understand why she was surrounding herself with them. You'd had interesting friends in college and I'd taken them as my own, but as the two of you stood scrutinising Lena's rickety old piece-of-shit countertop, she talked about the stain as though it were a blood infection the kitchen had contracted through overexposure to me. All the while I stood there, shaking my caffeinated head as if to downplay the size and permanence of it, with no sign of being pissed off that you were pissed off that I did not want to hang out with those people I was sure I would not be able to stand. Was it then that I told her that I had not come to Munich to socialise?

from our bags, we walked at a funereal pace. You'd made this trip a couple of times already: past the pretty bars of Rotkreuzplatz, past the Kaufhof on the corner and a less fancy supermarket after that, coming eventually to a quiet tree-lined street, getting closer to the bottle bank, just next to the canal. Every fifty yards or so, we had to stop and drop our bags, catch our breath and squint into the distance. At some point, Colette met my eye. Had she told me about the article she'd been editing at work that week, she asked? I sensed she was about to start complaining about work and, without knowing why, I felt briefly irritated. Colette was a righteous person. She complained often and for the most part entertainingly. She was probably at her best when she complained. So why the sudden chill of irritation? No more than a week had passed since she had sat you down at the edge of our bed and said it felt like we were living separate lives here. If something didn't change soon, did you not think it would be better if we broke up? You had always figured that if anyone was going to end our relationship, it would probably be you. I figured she was bluffing. I could not imagine her quitting such a long and storied relationship over something so trivial as me refusing to spend time with the bunch of random weirdos she'd met only recently and about whom she often spoke ambivalently. And so, with our bags squeaking down the street, through showers of dappled light, our footsteps crossing large amorphous coverlets of shade, fringed here and there with the shape of all the luminous leaves above, things really didn't seem so bad. Evening kind of changes things, I thought to myself, before I said, smiling, that, no, as far as I could remember, you had not told me anything about work that week. Quietly high-pitched, like the mischievous dog in

Wacky Races, you wheezed a little laughter out, almost rhyming with the squeaking bags, before beginning to tell me about the essay you'd been editing by a prominent biologist who'd spent the last five years researching the *matsutake* mushroom. Apparently a delicacy in Japan, you said, thanks to improvements in the quality of Japanese soil following the war, it had become so rare that Japan now had to import it, at great expense, from Canada, the United States, Mexico, Turkey, China and South Korea. As we pulled up at the bottle bank, which looked onto the canal where in winter the ice had been so thick that crowds had come to skate along the surface, I could guess where this was going. In a restaurant in Seoul several months before, I had accidentally eaten a mushroom, which happened to be one of the many foods I used to say I hated having never actually tasted it. Instantly, I knew I'd been wrong. I did not hate mushrooms. Quite the opposite. I loved mushrooms, loved everything about them: the taste, the texture, the whole idea of a mushroom. I had become obsessed with mushrooms, eating a wide variety of them so often and in such quantities that I had felt it necessary to sign up to an online forum for mushroom enthusiasts in order to ensure that my daily intake of mushrooms was not enough to kill me. I set my bags down by the bottle bank and squinted hard into the light reflected on the sleepy ripples of the canal. So, I said – feeling a little faint – what was so funny about this mushroom? Weren't you just laughing about a mushroom? What? A few seconds ago? Wasn't you? Oh that, she said. That had only been about the essay's title, in which the author, the prominent biologist based in Canada, had described the *matsutake* as 'charismatic'. *A charismatic mushroom,* she laughed. A duck came down diagonally and landed on the canal,

ten-minute commute with you, so that at least once every day you would see me not wearing pyjamas. A transparently superficial gesture of compromise, you might say, but my suspicion was your turn from me had something to do with what you perceived as a lack of occupation, and work so vague as to seem like a glorified excuse to sit at home doing nothing all day. In any case, I remember those mornings fondly, the trains all packed with people going to work. I had never seen Munich during rush hour before. Was it the Hauptbahnhof we had to switch at? Perhaps it only felt that way. Neither of us was ever in much of a hurry, but we seem always to have run for the second train to Universität, the U-Bahn station out of which we would emerge, together, onto the white, cream and yellow facades of Ludwigstrasse. Its neoclassical buildings were so bright that in the morning sun, they were not a little sore to look at. Sometimes you'd slink out of the library to the museum. That veil seemed less amusing every time. If the name 'Veronica' really was a portmanteau of *vera* and *icon* (it wasn't) meaning 'true image', then the woman's name anticipated this historically significant moment in her life, the impression left upon the veil. Well, you thought, standing before it one day, nominative determinism was one thing but this was quite another. You took a pen and notebook from your bag. Whoever this woman was had been concealed behind the veil, the *vera icon* after which she had come to be known. Added to this, the same fate had befallen the painter who portrayed her, remembered simply as the Master of St Veronica. With the chaotic excitement of one still at that age where nothing seems more impressive, more profound or intellectual than a *mise-en-abyme* observed, you were scribbling theories of Veronica in

complete with all the dark fetishistic connotations which that gooey chocolate mint evoked. You burped with your mouth open as you began making your way towards the park. You called me, but the call rang out. Once, twice, three times, four. The park was too large to go looking for me, so you cracked open a beer and on a bench in the shade you sat waiting for my call. I whispered *ten minutes*, whispered *fifteen*. Ludwigstrasse looked all buttery in the slowly setting sun. Soon you needed to piss so badly that you thought of that time in Korea, on the bus to Busan, when you'd started drinking so far away from our final destination that, after about forty-five minutes of your moaning, I'd thought to hold a scarf over you while you attempted to piss into the bottle you'd been drinking from. In the seats behind us and beside us, some friends thought I was giving you a hand job, but it was nothing so glamorous as that. Your bladder was so full, you winced, that it felt like you were about to burst. But with the bottle-neck wrapped so tightly around your dick, for about twenty-five minutes the piss just wouldn't flow. Maybe we'd gotten too close. I don't know. Now the first chill of night came onto me. I seemed to face across a deep sad plain. Shoving the beers into my satchel, I dashed across the wide empty street and used the toilets in the Staatsbibliothek. It crossed my mind to walk up the marble staircase and wait for Colette up there, but more than half an hour had passed and she still hadn't called me back. One can rely too much on the unspoken things, the wry smile. Half of me loved you, half was just honouring a promise. The train had already pulled in at Universität when you finally called me back. I watched the driver leave the train. You apologised for the missed calls. I watched

138

another driver replace him. Then you asked. Was I still around? I told you it was okay. Don't worry. I understood. It was easy to get distracted, especially with the weather still so fine. The carriage doors yawned open that bit longer than usual. I told you I was already on the train. Now backward into darkness I stared blankly.

[But I Did That to Myself]

Particularly toward the end of his life, and in view of the limited success of his work, Baudelaire more and more threw himself into the bargain. He flung himself after his work, and thus, to the end, confirmed in his own person what he had said about the unavoidable necessity of prostitution for the poet.

— Walter Benjamin. *The Arcades Project* (trans. Howard Eiland and Kevin McLaughlin).

It's nice you called.
Nice, why nice?
Just because. It's nice of you.[13]

Ingeborg Bachmann finished just a single novel in her lifetime, but she is nevertheless regarded as an heir to the tradition of Robert Musil and a central influence on a generation of outstanding German and Austrian novelists, not least of them Christa Wolf, Peter Handke and Thomas Bernhard. Published in 1971, *Malina* is an immensely ambitious work, a masterpiece of European modernism, traced in the dust of the Austro-Hungarian Empire, and currently out of print in English. The first volume in what was to be a large prose cycle entitled *Ways of Death*, *Malina* has three central characters, each representing a distinct Austro-Hungarian cultural type, yet each convincingly singular in their own right. The narrator is a well-known Viennese author in her late forties, an unnamed woman who has suffered from depression much of her life. In recent months she has fallen in love with Ivan, a slightly younger man from Budapest, on whom she bestows 'the highest distinction' for 'rediscovering me as I once was'. Since meeting Ivan, the sound of her typewriter has softened; doors no longer slam with such a bang; birds sing more quietly, allowing her a second sleep. 'At last I am able to move about in my own flesh again,' she writes, opening up the novel, 'with the body I have alienated with a certain disdain.'

[13] Ingeborg Bachmann. *Malina*.

Although it all took
place in silence,
almost with
complete indifference,
you could still describe
what went on as a
nightmare, the whole city
participated in this
universal prostitution,
everybody must have lain
on the trampled lawn
with everyone else or else
they leaned against
the walls, moaning and
groaning, panting,
sometimes several at a
time, by turns,,
promiscuously.[14]

[14] Ingeborg Bachmann. *Malina*.

Out of the corpse-warm foyer of heaven steps the sun.[15]

Having completed a doctoral thesis on Martin Heidegger and the limits of poetic language after fascism, Bachmann went to Munich in 1952, where to the Gruppe 47 gathering of post-war German writers she read in a near-whisper a series of early poems, touched by a sublime, surgical lyricism. The reading brought Bachmann to immediate prominence. Her work was published in all the leading journals; and within two years, her face was on the cover of *Der Spiegel*. Referring to her work in 1958, Paul Celan spoke of a language which 'wants to locate even its "musicality" in such a way that it has nothing in common with the "euphony" which more or less blithely continued to sound alongside the greatest horrors'. After two widely acclaimed poetry collections – *Borrowed Time* (1953) and *Invocation of the Great Bear* (1956) – Bachmann was living in self-imposed exile when she turned to prose; developing a narrative style animated, like her poetry, by the trill of something unspeakable. 'Society is the biggest murder scene of all,' says the narrator in *Malina*'s most frequently cited line. 'In it the seeds of the most incredible crimes are sown in the subtlest manner, crimes which remain forever unknown to the courts of this world.'

[15] Ingeborg Bachmann. 'Message' (trans. Peter Filkins).

Malina doesn't want
any portrayals
and impressions of
some dinners I once
spent in the company of
murderers. He would
have gone all the way
and not contented
himself with a mere
impression or this dull
unease; he would have
presented me with the
real murderer and used
this confrontation to
force me into a
realization.[16]

[16] Ingeborg Bachmann. *Malina*.

Certainly I was subordinate to him from the beginning.[17]

Malina is the person with whom the narrator lives: a forty-year-old civil servant; a one-time author; an obscure, androgynous figure to whom she sometimes refers as 'Lina', using feminine pronouns. On a side street in Vienna's Third District, Malina's scrupulous presence hangs hard over the apartment where together they've both been living for some years. 'His listening insults me deeply, because behind everything that's said he also appears to hear things unsaid – also that which is said too often.' Forever on guard not to disturb Malina, the narrator must take care that, when Ivan is visiting, the two do not 'encroach upon each other'. After Ivan has left and Malina has returned to the sitting room, no mention is made of Ivan. By speaking as though Ivan does not exist, Malina precludes any discussion of his own unease, discomfort, even jealousy. He studies the chessboard and, judging where the pieces have finished, he makes an ostensibly light-hearted remark about the low standard of play. The apartment is charged with passive aggression, but even if Malina is silent, explains the narrator, 'it's better than being silent alone, and it helps me with Ivan, too, when I can't grasp what's going on, or when I lose my grasp on myself, because Malina is always there for me, steady and composed.'

[17] Ingeborg Bachmann. *Malina*.

I have stepped
into the mirror, I
vanished in the mirror,
I have seen into the
future, I was one with
myself and am again
not-one with
myself. I blink, once
again awake, into the
mirror, shading the
edge of my eyelid with
a brush. I'm able to
give it up. For a
moment I was
immortal and I – I
wasn't there for Ivan
and wasn't living in
Ivan, it was without
significance.[18]

[18] Ingeborg Bachmann. *Malina.*

A handful of pain vanishes over the hill.[19]

Set in Madrid like most of his films, Pedro Almodóvar's *Women on the Verge of a Nervous Breakdown* (1991) lifts so many of *Malina's* scenarios, motifs, metaphors, formal conceits, even character names that Bachmann ought to have been given some kind of credit. Pepa is a voice actor who, unable to get in touch with Ivan, is convinced that he is preparing to leave her. Making gazpacho laced with barbiturates one afternoon, she drinks a mouthful and decides to start smoking again. 'I'm sick of being good,' she says to herself, but right after lighting the cigarette, she changes her mind. Flicking the cigarette away, she accidentally sets fire to her bed. Almodovar shows her face turned pink with the light of flames at which she stares, her eyes glistening, dramatic strings rising on the soundtrack. Moved or not, she does not move, until her lungs have filled with smoke, to put it out. In *Requiem for Fanny Goldman* (a fragment of Bachmann's unfinished cycle, *Ways of Death*) a thirty-year-old man called Marek publishes a book in which he exploits everything his lover has told him 'at night when she was lying next to him, in the afternoon when they were strolling through the woods, when they were bicycling or drinking coffee'. In 1973, at the age of forty-seven, Bachmann died as a result of a fire in her apartment in Rome. Parts of *Ways of Death* must have gone with her.

[19] Ingeborg Bachmann. 'Early Noon' (trans. Peter Filkins).

The men read the
sheets of paper spat
out by the teletypes,
they cut, pasted and
collated. I just drank
coffee by myself and
smoked, they would
toss reports on my
small table with the
typewriter on top,
reports chosen on a
whim, and I would
rewrite them into clean
copy. I wound up
becoming thoroughly
familiar with whatever
news would wake
people up the
following morning.[20]

[20] Ingeborg Bachmann. *Malina.*

Me: Since when do we have a crack in the wall?
Malina: I don't remember, it must have been there a long time.[21]

Full of beautiful, biting digressions on submission and control, the abuses of the second person familiar, the fate of the postal officials, and what the narrator calls the 'disease' of men, *Malina* is a novel which, in the despondent charisma of its essayistic voice, could be said to anticipate the fiction of Renata Adler. Yet *Malina* is the stricter, denser, more heteroglossic work; a rhetorical collage in which the first-person narrative is regularly interrupted by less orthodox modes of literary speech: phone conversations, interviews with the press, official and private correspondences; spaces in which the person addressed is not the reader exclusively. When the critic Helgard Mahrdt describes 'the deformations of subjectivity and sensuality' that result in *Malina* from 'the penetration of instrumental rationality into the private sphere', she is speaking not just about the narrator as a subject, but the body of text as well. Correspondences and interviews establish a reality-effect, lending the text an air of objectivity, rationality. Even the intermittent observation of these third parties is enough to control the first-person narrative. The novel submits itself to an internalised discipline: it is an observation machine; a household with its very own Malina. At a certain point Ivan stops calling or answering. Soon the narrator feels less able or inclined to write letters. In their absence, the pages become dominated by extended dialogues between the narrator and Malina, and passages from atonal musical scores. The first-person speaker grows increasingly unstable and fragmented. The novel cracks and collapses, deforms.

[21] Ingeborg Bachmann. *Malina*.

[Death Cycles]

The egg is a suspended thing. It has never landed.
When it lands, it is not what has landed.

— Clarice Lispector. 'The Egg and the Chicken' (trans. Katerina Dodson).

Allee. Making my way down Nymphenburger Strasse, I passed the Volkstheater and the Löwenbräu beer hall before arriving at Königsplatz, a square surrounded and marked by four imposing neoclassical buildings modelled on the Acropolis of Ancient Greece and built during the nineteenth-century reign of Bavaria's King Ludwig I. I was always a little bit shocked whenever I approached the square: it seemed to arrive from nowhere, then all at once it was everywhere. In any case, monumentality was not an issue for Hitler. In 1935, he turned the square and surrounding buildings into the epicentre of Nazism, paving over trees and shrubbery with twenty-two thousand square metres of granite slabs: an appropriate space for mass rallies and book burnings in 'the capital of the movement'.

How best to deal with Königsplatz was an issue of great concern for architects and planners in the years following the war. On the east side of the square, the Nazis had constructed a pair of *Ehrentempel* – 'Temples of Honour' – dedicated to the sixteen 'martyrs' of the Beer Hall Putsch. Early post-war debate over these two sites, where the exhumed bodies of the sixteen had been interred in bronze sarcophagi, would set the tone of disagreement through the overall process of denazification, such as it was. Many called for the complete demolition of the temples. The architectural historian Hans Eckstein argued that anything short of a radical purge would give the unwanted impression that 'we could not separate ourselves from such monumental remnants of the Nazi empire'. Others pushed for a policy of normalisation, whereby Nazi buildings and monuments, such as the two *Ehrentempel*, would be given new functions, recontextualised. Eberhard Hanfstaengl, the director of the Bavarian State Painting

Collection, wrote in December 1946 that such an approach would be an effective means of preventing the 'immortalisation of Nazism'. The process of 'radical elimination', by contrast, would 'awaken memories of brutal Nazi methods that one wants to avoid'.

In January 1947, the city demolished the two temples only to discover that, due to a series of technical and safety issues, their foundations, each covering its own four-metre-deep underground bomb shelter, would have to be left intact. Then, in the late 1980s, the city planning office began to receive phone calls from a variety of interest groups calling for the complete and final demolition of the foundations.

I had passed through Königsplatz frequently over the previous few months. The sheer size and obviousness of the buildings had made the square a natural first port of call whenever friends came to visit. I would show them the so-called 'botanically normalised' areas, the architecturally vacant spots where the temple foundations stubbornly stood for so long, and would often remark, as if I'd just had the thought, that the trees and bushes planted in place of the foundations seemed to draw attention to a spot that for political reasons was not permitted to be emphasised. Depending on the day and the guests in question, I would sometimes continue by noting that erasure is never anything more than a particularly profound form of preservation. There was a certain satisfaction to be taken in making an unobvious comment like this. It derived, I think, from the will to say something that is authentically one's own. Yet the line about erasure is not mine: it is copied exactly from another writer, working in another context.

○ ○ ○

And as a matter of fact, the erased foundations were never actually demolished. When I first edited this piece, more than a year after writing it, I became aware of my error: I had been bringing friends to the wrong location, a spot across the road where no temple ever stood, where nothing except trees seems ever to have stood, and I had told them that these particular trees were a clear, if indirect, representation not only of Nazism, but of the attempt to cover up the Nazi past. Across the road, on what were the actual former sites of *Ehrentempel*, trees and bushes had been planted not in place of the demolished structures, but on top of their still-intact foundations.

○ ○ ○

Remembering that the Munich College of Music occupied the building formerly known as the Führerbau, where, in Hitler's second-floor office, now a rehearsal room, Neville Chamberlain signed the 1938 Munich Agreement, I stopped my brisk walk towards Marienplatz. Above both entrances there was a notable interruption to the second-floor facade: where there ought to have been a window, instead there was a blank space marked by three small holes. Here, hooks had once been installed to support statues of the Nazis' national symbol, the eagle. At Odeonplatz, I looked to my left and took in the grand Ludwigstrasse stretching all the way out to the Siegestor, a commanding arch in half-preserved ruins, which marks what was once considered the entrance to or exit from the city. I turned right, however, moving on towards the *Altstadt*,

passing the west wing of the Residenz, an enormous complex of buildings and courtyards guarded on this side by two green lions of luxurious mane and a Mary much more ferocious than the one in the apartment. During the Second World War, the Residenz was bombed by the Allies to almost total destruction. Before the war, it had been covered by 23,500 square metres of roofing. Only fifty survived. Whereas the contested legacy of Königsplatz centred on its relationship with Nazism, the Residenz had been known as the seat of the Wittelsbach monarchy. With parts of it dating back to the fourteenth century, the alternately baroque, rococo and Renaissance palace served to anchor the city's sense of itself and its place in history. Citizens and civic leaders found it difficult to imagine a city plan without it. The powerful lobbying group Freunde der Residenz declared: 'We do not want to give up the heavily damaged monuments of our culture, for it is this culture that secures for us, in the wake of the collapse, a fully valid place in the community of nations.' It fell to the architectural historian Wolfgang Lotz to object. 'It was the intactness of that which was historically evolved that composed the actual meaning of the old Residenz,' he argued in 1949. 'Even the most faithful attempt to reproduce that which was destroyed would evoke for the viewer that unfortunate feeling of falsified history.' His appeals were ignored. Over the course of the 1950s the exterior facades of the Residenz were fully restored to their pre-war condition, with just a few interior concessions to modernist calls for renewal.

The same pattern of debate was to play out again and again in a city where almost half of all buildings were either heavily damaged or completely destroyed by the Allied aerial bombing

campaign of 1943–5. Among the first buildings to receive the public's post-war attention was the Peterskirche. Built in the twelfth century, the city's oldest church suffered severe damage to its tower, roof, nave and choir, as well as its variously baroque and rococo interior. The Peterskirche was reconstructed to its pre-war form under the guidance of Rudolf Esterer, a leading theorist of historic preservation; it was reported approvingly that church officials were unable afterwards to tell which parts of the building were new and which were original. Shortly after that the late Gothic Frauenkirche would be reconstructed as well, much to the delight of the general public; and the supposed success of these two traditionalist projects would inform the city's general approach to putting itself back together again. Munich became one of the most thoroughly, and conservatively, rebuilt cities in all of Germany. The districts I was passing through had more or less reassumed their pre-war appearance. Munich was a reproduction.

○　○　○

Arriving at Marienplatz, I stood before the Altes Rathaus, the old town hall, which had been heavily bombed during the war. Torn down in 1944, its neo-Gothic tower had not been reconstructed along with the rest of the building in 1955, and seven years later the writer Anton Sailer could ask: 'Who recalls any more that our old city hall once had a picturesque tower that had to be sacrificed in the last war?' It will never come again, he lamented. In 1966, however, several members of the city council proposed rebuilding the tower as a 'crowning end point of the pedestrian zone'.

On my right, on Mary's left, a country road extended into nothing but more country road. This must be the wrong end, I thought. I turned and walked back past the U-Bahn station and onwards until I reached the other end of Salzmesserstrasse. It looked pretty much the same as the other end, but I turned right onto Linnenbruggerstrasse nonetheless. An old man on a bicycle, moving much slower than one would imagine necessary to stay upright, put me in mind of my own grandfather, who was once pictured cycling gracefully down O'Connell Street on the front page of the *Irish Times*, a copy of which my mother recently tracked down and presented to him as a gift. Something about this memory-work transfigured the old man's benevolent wave. It was a matter of distress for me. There was nothing perfunctory about his gesture, nothing merely polite. He had waved with such familiarity, such affection, that I would not have been surprised to learn he had mistaken me for a lifelong resident of these parts. A little fazed, I continued straight on to Am Mitterfeld, a busier road which, although it made no sense according to my map, seemed somehow more promising. When I saw the posters on its every lamppost seeking a family dog gone missing since September, I thought of Patrick Modiano, the French writer whose novels, all told by narrators lost amidst the cyclic topography of Paris and the past, are packed with missing dogs that signify nothing so much as the impossibility of shrugging off memory. '*Wer hat ihn gesehen?*' the poster asked, the same question I'd been trying to answer all day. Against my better judgement, I turned right up Am Mitterfeld where, perched above the garage of a yellow semi-detached, I spotted a dark copper owl waiting patiently for dusk to fall.

It was not without some dismay that I stopped about a hundred yards later at a less than sacred-looking tombstone shop. It was not just that the place called attention to itself with an enormous billboard outside. Nor was it just that the words on this billboard had been printed in a font that made each letter look like a tombstone. What really got me, I think, and I was not a religious man, is that the 'T' in the shop's name – 'KOMETER' – was signified by an enlarged and cartoonish crucifix. Beneath the billboard, like a poster for *The Life of Brian* designed by a man who cut his teeth selling bargain-priced mattresses, there was a rather ominous forecourt full of unmarked tombstones. What these memorials awaiting their memory served to remind me was that suburbs such as this speak less of the past than of the future. It wasn't until 1957, when the city's population reached one million, that residential Munich began to expand to these peripheries. As the city approached its eight hundredth birthday in 1958, the official festivities proclaimed 'Munich Is Munich Again'. During the anniversary year, at least half a million people watched a torchlight parade depicting approved historical figures from Munich's past. On Ludwigstrasse, the formerly militaristic Siegestor arch was reconstructed and newly inscribed on its southern facade with the legend 'Dedicated to Victory, Destroyed by War, A Monument to Peace.' Near Marienplatz, the famous Hofbräuhaus was reopened to the public. And, at Munich-Riem Airport, on the former site of which I was now standing, British European Airways Flight 609 was bringing the Manchester United squad back from their victorious European Cup quarter-final in Belgrade when, on the third attempt at take-off, the aircraft hit a bank of slush, losing the velocity necessary to

leave the ground, whereupon it skidded to the end of the runway and through a fence before crashing into a family home, which promptly caught fire. Of the twenty-three players, staff members and journalists killed, the youngest were Duncan Edwards (aged twenty-one), Eddie Coleman (twenty-one), David Pegg (twenty-two), and my granduncle Liam Whelan (twenty-two), a devout and homesick Dubliner who spoke his final words on the edge of this frozen foreign city: 'If this is the time, then I'm ready.'

Liam Whelan was born on 1 April 1935, but the fact that today would have been his seventy-eighth birthday was actually a matter of complete chance. This was no anniversary pilgrimage. In anticipation of my return to Dublin, my mother had asked on several occasions that I photograph the two memorials there to show to my grandfather, an infrequent traveller who, not having visited the site where his younger brother passed away, had never seemed to achieve any real sense of closure on the events, his stories always drawing upon a well-kept index of if-onlys and what-ifs. In the hallway of his current home there is a crucifix and a picture of Pope John XXIII and a black-and-white Manchester United team photograph in which Liam is sitting in the front row, second from left. Taking a few steps beyond this idiosyncratic trinity, moving into the dining room, we come face to face with a posthumously painted portrait of Liam dressed in sharp United red. Moving upstairs, if we know where to look, we find stored in some casket, chest or wardrobe the four felt-green, gold-lined caps my granduncle won playing for Ireland, as well as a collection of match programmes and newspaper clippings dating back to when Liam was playing – first for Home Farm, then for United.

My grandfather was just a boy when he lost his father to tuberculosis. As well as being a brother to Liam and his sisters, it fell to him to assume a sort of fatherly role. At fourteen he left school to work for Dublin Corporation. When the Manchester United scout came to the house looking to sign Liam, it was my grandfather who advised his mother to permit the move. When Liam later complained of homesickness in Manchester, it was my grandfather who put him in contact with a family he knew from home with whom Liam was to lodge. And when, all too shortly after, the time came to organise Liam's funeral, it was my grandfather again who, placed in charge of the proceedings, consented to Glasnevin Cemetery's suggestion that Liam not be buried in the family plot for fear that the graves surrounding it would be destroyed by the abundance of mourners at what turned out to be the third largest funeral in the history of the state. It was decided instead that he would be buried in a new pathside plot near the south St Paul's entrance. My grandfather has always been pleased that Liam's grave should be so public. Fondly he recounts the story of a man who, around the time of the fortieth anniversary of the crash, was unable to find the grave unaided because the Whelan family name had been obscured by an extravagance of flowers. There are many stories; my grandfather tells them often.

Liam's tomb was the first public memorial to him. But many more would follow. At Manchester United's stadium, Old Trafford, there is a commemorative plaque in what is known as the 'Munich tunnel'. Outside the ground, the time the crash took place is regularly commemorated on the 'Munich clock'. There in the suburb of Trudering, the site of what was once Munich-Riem Airport, two memorials marked the crash. One, erected by

the residents of the suburb, was a small wooden affair depicting another Christ on another cross. I stood in front of it for some time, waiting, I don't know why, before I walked a little closer, taking in its memorial inscription. Then I noticed something strange: a pin badge no larger than two centimetres square had been pressed into the board on which the cross was hung. It was shaped to resemble the current Manchester United mascot, a red devil with a pitchfork. Then I walked perhaps thirty metres down the road until, at the intersection of Emplstrasse and Rappenweg, I came to the second memorial, situated at a spot now known as Manchesterplatz. Here, the memorial erected by the municipality of Munich named each victim of the crash. I was not a little appalled when, at the rather uncanny sight of my granduncle's name there in Munich, I attempted to conjure some remembered image of his memorial much closer to home. I found I was unable to do so. In fact, I now realised, I had never actually gone to see it.

I didn't know where I had been when they unveiled the Liam Whelan Bridge, nor do I remember ever seeing the fifty-five-cent stamp with his portrait printed on it, though just five years had passed. I had little memory of the time, a mental blank that in some ways parallels the way I had always felt about the tragedy itself. For me, my granduncle's death in the Munich Air Disaster had always been something interesting to tell taxi drivers, or a way of tempering a United fan's disgust when I told them I supported Manchester City. Still, it struck me as strange, not to say insulting, that I had not attended the ceremony at which Bobby Charlton, himself a survivor of the crash, unveiled the Cabra bridge named in my granduncle's honour.

Home Farm FC, where my grandfather's friend Liam Tuohy, who had also played for Ireland in the late fifties, was in charge of the youth programme. I was very much aware even then that I was taking part in the reconstruction of Liam Whelan. It was often said that I could read the game in a similar style to his, that I was of the same build, and that my growth spurt would arrive soon, by the time I reached twelve or thirteen, just as his had. A few times I was even told that our faces resembled each other exactly. In truth I could never quite see it, but I convinced myself that I did. I would go to Ireland matches at Lansdowne Road and overhear my grandfather tell his friends in the surest tones: *Remember this lad's name, he'll be in an Ireland shirt soon.* On the eve of the fortieth anniversary of the crash, a reporter came to my grandfather's house to take a photograph of the two of us looking fatefully out the window, me into the future and my grandfather into the past and both in the same direction somehow. There was an anniversary Mass the next evening. The church was packed. My entire school seemed to be watching as I walked carefully down the aisle, bearing a Home Farm jersey imprinted with the same number Liam had worn. I placed it at the foot of the altar at last. There I stood, rapt, as the choir, my classmates, the entire congregation started triumphantly into 'Glory, Glory Hallelujah!' How could I, a child of just eleven, think of this as anything other than the sacrament of the resurrection of Liam Whelan?

My mimetic growth spurt came too late. At fifteen, I was too small to compete and had lost all interest in playing. I rarely started a game any more, and I was pretty much bullied at every training session. I quit playing for Home Farm, then quit playing

football altogether. I took no note of new referees, and even forgot the old ones. I started skateboarding. Liam had never skated.

O O O

And so it is from a certain psychological distance, I recall, one I regret but can't recover, that I reach at last for my camera. I align the eyepiece to my right eye, shut my left eye, and then frame this photograph of Manchesterplatz. I click the shutter release now and then I hear, roaring through the back of my mind, an audio hallucination of steel scorching into asphalt, an inherited memory of my granduncle's death on this very spot some fifty-five years ago. I look to my right and realise I'm not hallucinating. A man is bawling out in pain. He has crashed his motorbike just four or five feet from the memorial. Sparks continue to strike off his bike until at last it comes to a stop. He struggles to free himself from under the bike and I just stand there, motionless, my mouth agape, my eyes spilling over with tears. He is in urgent need of help and still I just stand there, my mind bombarded by questions I will never know the answers to. What does it mean for this man to crash his bike during the only ten minutes I have ever spent, and probably ever will spend, at the site of my granduncle's own vehicular death? And what does it mean for it to happen, quite by chance, on what would have been his birthday? A woman stops her car and helps the man to his feet, but he cannot stand upright. As he lies back down in agony, I notice there is oil leaking from his engine. On that night in 1958, there was a danger that the crashed plane would explode; yet goalkeeper Harry Gregg defied the call to flee so that

he could pull others from the wreckage. Not me. First I take a photograph. And then I leave the scene, in a hurry. As I pass the tombstone shop a second time, an ambulance flies past and I think what a terrible thing it is to wish for grief. I find the U-Bahn station without a single misstep now. I keep my head to the ground, still struggling to breathe regularly. A postwoman is doing her rounds. She is speaking very loudly into some manner of headset. But I still don't understand German – and to me, it all sounds like reproach.

III : ASH

[Shape of Silence]

On a spring afternoon in 19—,
 the year in which for months on end
 so grave a threat seemed to hang
 over the peace of Europe, Gustav
 Aschenbach had set out from
 his apartment on the
 Prinzregentenstrasse in
 Munich to take a
 walk of
 some

length by himself.

— Thomas Mann. *Death in Venice* (trans. David Luke).

— Stephen Shore. *Room 125, Westbank Motel, Idaho Falls, 7/18/1973*

Across the brittle brownish gold of the television set, the spewed amber of the large leather suitcase, the dandelion quilt of the dreary little bed, the drab familiar tan of the table and chair, and the mustard drapes – an intersecting pair of navy jeans and two white Converse sneakers have intruded, with studied nonchalance, from the bottom of the frame. Mirroring the off-white lampshade and the aqua-blue on the television screen, they have instituted, within the shot, an alternate colour scheme. It is 18 July 1973, and Stephen Shore is sitting in Room 125 of the Westbank Motel in Idaho Falls, Idaho. It has been four years since the first time he visited Amarillo, in the company of a friend. 'I couldn't drive,' Shore recalled of that first trip. 'I watched it all from the passenger seat.' Having sold work to Edward Steichen at the age of fourteen, and produced an epochal collection of portraits and scenes from Andy Warhol's Factory before turning eighteen, Shore had not taken long coming good on the promise of this Rimbaudesque juvenilia. Unlike Rimbaud, who went off to sell arms in North Africa, Shore continued to practise into his twenties, becoming the first living photographer since Alfred Stieglitz to have a solo exhibition at the Metropolitan Museum of Art, with a selection that included a sequence of black-and-white photographs taken, in motion, at the end of every block as he walked towards Central Park. 'I found having a show at the Met a confusing event,' he said. 'In some ways I was too young. This is what everyone hopes for, then it happens and you think, "Oh my God, now what am I going to do?"' The following year Shore got back in the passenger seat of his friend's car. He had rarely left Manhattan all his life, yet this was the third time he had set out for Amarillo. 'The food', he recalled, 'was terrible.'

On the second trip, in 1971, Shore assigned himself a role, acting as if he were a professional photographer, commissioned by the city council to portray the 'local highlights'. After producing a set of ten postcards (on which the name Amarillo did not appear) Shore and his friend set off again, distributing the postcards, without any ceremony, in gas stations, guesthouses and grocery stores across the country. On this trip, Shore took the photos that would make up *American Surfaces*. Shot with an ordinary 35 mm Rolleiflex, exposed onto ordinary Kodak film and developed in an ordinary Kodak lab, hundreds of these ordinary 3 x 5½ tourist snapshots were hung, unframed, in rows of three, on the walls of a small room at the back of the LIGHT Gallery in New York in 1972. Made using a method Shore would later describe as 'taking a screenshot of my field of vision', they formed a gridlock of banal, haphazardly framed non-moments (which Lynne Tillman describes as 'close-up, sometimes tawdry, even abject'). The inside of a fridge. A halogen bulb on a ceiling. A filthy flooded toilet seat. A crusty egg, spent on a plate. And somewhere, almost always, the harsh glare of the camera's flash. The show stayed open for three months, but the reviews weren't good. Owing in part to the banality of the content, and in part to its use of colour, even sympathetic interpreters of Shore's earlier work expressed scepticism. Ansel Adams advised that a spiritual photograph could not be achieved using colour. His mentor, John Szarkowski, was less prohibitive. Yet in questioning the accuracy of the Rolleiflex's viewfinder, the institutional voice made itself quietly clear. He went, next time, with the large-format.

Though the landscapes in *Errance* are in portrait format, Raymond Depardon's slim volume sees an aesthetic much like Shore's taken up, interrogated and poeticised. 'But how with a photographic apparatus', he asks, 'am I to represent this notion of *errance*? The photographic act is such a short moment. How can one imbue it with traces, with a body, even a duration?' As Shore never tires of repeating, any given photograph might require as many as thirty minutes of his *looking* before the frame is ready. Depardon requires something other than this. To present a body in time and space, the photographer must identify 'what the Germans call *Einstellung*'. Though he defines the term briefly as 'how one situates oneself in relation to what one shows, and at what distance', the dictionary lists half a dozen other meanings, all of them disparate yet related.

attitude (*nf*)
political views (*npl*)
recruitment (*nf*)
enlistment (military) (*nf*)
shot (film) (*nf*)
setting (*nf*)

Shore has spoken of the fine margins at work in the construction of a photograph's meaning: a traditional landscape can turn into a comment on tourist society in three paces. Depardon, seeking his *Einstellung*, resolves to make vertical photos in which 'the horizon divides the frame in half (too much sun, too much sky) to establish my position, to mark my presence, and prevent me from cheating.'

Between the speckled mustard motel drapes, a tall bisected window occupies the left of the frame. Stephen Shore is sitting on his bed in Room 125 of the Westbank Motel. Whatever is happening outside is unreadable behind the panel of celestial white the window contains. Having learned to drive in 1972, Shore set off yet again – this time on his own – with a tripod and an 8 x 10 viewcamera. The greater expense and exposure time forced Shore to radically reconsider his approach to framing. One morning he had attempted to take a picture of his breakfast, which had been a recurring motif in *American Surfaces*, but with the large-format camera, he needed twenty minutes to set the shot up. He had to stand on a chair. The offhand nature of the work was lost. Printed the same size as the negative, however, the extremely high resolution of the 8 x 10 images meant that the frame grew more capacious. The works in *Uncommon Places* are autonomous compositions, organising the world into intricate assemblages of colours and shapes, relating to each other across complex depths of field. Each exposure could accommodate a multitude. Of course, it is no accident the window comes out as it does. Blanched. Illegible. Negative space. Whatever went on outside in Idaho that day has been effaced by that white abstract panel of light with a claim on the spiritual. Was this the longest spell that Shore had spent alone?

In 2014 Shore was one of twelve international photographers to participate in *This Place*, an enormous group project curated by Frédéric Brenner; funded by over forty Western philanthropic organisations and trusts (and as many individual benefactors); and exhibited in five major art institutions in North America, Europe and Jerusalem. Over the course of two years Shore made six trips to Israel, five months in all, his expenses and accommodation paid, working closely with an enthusiastic Israeli assistant, Gil Bar, who suggested where they would shoot and drove him there. Violating the international cultural boycott of Israeli institutions that do not sustain strong opposition to the occupation, Shore worked amid 'this crazy web of energies', photographing the ancient landscape, the architecture, and what he calls 'average Israeli life'. Being in a group, he felt absolved of responsibility. He didn't feel he had to make anything 'definitive'. 'I was interested in what else was in Israel and the West Bank, other than the conflict,' he explained, in all the conversations. 'I was interested in the land. I was interested in how the land was built, interested in what the food looked like.'

'Something I derived from Warhol', Shore explains to Tillman, 'was a delight in our culture, a kind of ambiguous delight.' As he provides no further comment to this, and receives no further questioning from Tillman, it is not clear to me where the ambiguity of Shore's delight is supposed to lie. Though occasionally ironic, his eye is seldom, if ever, satiric; his eye, full of boredom and privilege, is apt only in stylish geometries. When he first set out to Amarillo in 1971, many of the states Shore passed through had spent the last few decades fighting to uphold the principle of racial segregation in law; and after that, devising housing, education and criminal legislation to maintain it in practice. Outside its Houses of Government, cheaply made statues had been hastily produced in honour of Confederate leaders who, a century before, had led hundreds of thousands to their death to protect the constitutionally enshrined institution of human chattel slavery, on which the vast wealth of these states, their economy, infrastructure, society, their very culture, was grounded. One photograph in *Uncommon Places* depicts the parking lot of a kitschified Native American-themed motel. Another – selected as the cover of *Uncommon Places: The Complete Work* – shows the parking lot of a restaurant chain whose name, printed in big letters twice within the frame, derives from a racist slur. Yet when Shore was asked by Baruma about the ethical issues raised by the practice of non-moment photography (an aesthetic with implicit claims to neutrality) in a country such as Israel ('where one has to resist the notion that even the landscape is guilty'), Shore began his response by contrasting it to working in the United States, where the space, he says, is 'not politically charged'.

Three weeks and 1,241 miles after Idaho, Stephen Shore is in Room 30 of the Sun n' Sand Motel in Arizona, where the walls are salmon and the carpet is brown. Above the desk is a mirror. In the corner of that mirror is the reflection of a print framed on the opposite wall, a riverscape told in familiar brown, white and aqua-blue. On the desk Shore shoots straight on, there is a phone; a lamp; a bowl; a glass; a folded-up newspaper (whose headline is not visible); a kettle; and most prominently, a television, in which is reflected a jaundiced-grey image of the motel bed, as well as the wall, and the riverscape, and a fragmented, distorted image of the photographer with his tripod. Every frame within a frame is a kind of signature. In the Westbank Motel, the white light blurs the screen with a thumbnail of the scene it conceals. It is a token of what has been excluded by the frame, now refigured in such mist, and at such distance, that it is difficult, if not impossible, to make anything out.

[The Lot]

At the window that veils her old
sandalwood viol voiding gold
which used to cast its glitter in
the past with flute or mandolin

is the pale Saint displaying that
old volume the Magnificat
unfolded, from which vespers or
evensong used to stream before:

at this ostensory pane draped
by a harp that the Angel shaped
in his flight through the evening shade
for the delicate finger-blade

as she is poising to caress
neither old wood nor old edition
but instrumental featheriness –
being the silence's musician.

— Stéphane Mallarmé. *'Saint'* (trans. E. H. Blackmore and A. M. Blackmore).

It was the middle of winter when I moved to Madrid, but I had not banked on the cold. In the beginning I lived alone in Lavapiés, a neighbourhood just south of Puerta del Sol, where the night I arrived the air smelled more or less of marijuana. My new Airbnb host introduced himself as Diego. He said he lived nearby, that he was part of an improv theatre company. Since this seemed to be more information than a tenant needed to know, I took it to be an offer of friendship. When I expressed a less than entirely sincere interest in seeing his company perform, Diego's demeanour changed to one of nervous excitement. He directed my attention to a series of framed photographs depicting performances held in the Teatro Lope de Vega so long ago that he could not possibly have had anything to do with them. Here, he said, is Aurora Bautista in 1962. I see, I said, though I did not. The photographs were printed on what looked like black crepe paper. They were dark and matted, and Diego seemed to have as much trouble as I did making out the figure of Aurora Bautista in 1962. Here, he said, moving on, is Maria Asquerino, also in 1962. I mean: Here. It occurred to me that the photographs were not worth framing. Perhaps it occurred to him too. Anyway, he seemed to remember his purpose. He said he'd call next time there was going to be a performance. He demonstrated how to fix the heating should it stop working and he showed me how to lock the door. Then he said goodbye. He did not call for almost a month. When finally he did, it was to let me know that the apartment would undergo a routine fumigation later in the week. Only six months had passed since the first time I'd visited Madrid, shortly after my brother and his girlfriend moved into a place just off Gran Vía. I stayed with them that weekend – we bought imitation sunglasses,

summer, before she went away. I was probably not as discreet about it as she would have liked, but nobody died. Joan had the measure of me. She'd had it since one afternoon when, in a quiet pub, weeks after we met, I attempted a live oral translation of a passage that I had recently copied into my notebook by the philosopher and literary critic Maurice Blanchot. Joan was as alert to the pomposity of Blanchot as I was incapable of translating him. Still, it should not have been so difficult. Not only had I left college with a French degree, I had also read the passage a few times in English before deciding that only Blanchot's original French could suitably adorn the inside page of my notebook. It felt like a long time before I'd managed to get through half a sentence, more words skipped over than even guessed at, and Joan told me I should stop, just stop, and I stopped. The silence did not lift until at last she looked at me.

She said: 'Well, that was excruciating.'

She said: 'Do you want another drink?'

We went to the cinema twice that summer. The second time was late September, the weather fine, at that point in the evening when sunlight is still visible only on the highest windows of the city, of Liberty Hall, say, or Hawkins House behind the Screen Cinema, where we sat in the back row of a bad movie to kiss. As the film started rolling it was only us in darkness. Our unspoken plan seemed to be working until, several minutes later, light flooded in through the theatre door, followed by a solitary figure who made his way towards the back, choosing finally our row to sit in, whereupon we had to stop. The film took a long time ending. It starred Casey Affleck as a spurned lover, a wronged fall guy, something like that. I no longer recall the exact details. At around

this time Joan asked me whether I would have cheated on Colette with her, had we met a few months earlier. I did not know it then, but this was exactly Joan's style. I said no because I thought that what she wanted to hear was no. As it turned out, it was not.

In the photograph on my laptop, her hair looks a little lighter than usual and, given the circumstances, not nearly as wet as it should. She is in the bath, her face emerging from foam as in Klimt it would emerge from gold. It is 4 a.m. and she is alone. She couldn't sleep, she said. That was not unusual. She said that she could never sleep; but I had seen her sleeping. Shortly after she'd gone back to Oxford, I visited her there; on the last night, I spilt scalding hot coffee over her in a misguided attempt to *prevent* her from sleeping. I wanted her to stay awake. The next morning, I forgot to pack a pair of socks I had recently borrowed from a friend. Maroon wool, I remember, with white and I think mustard speckles; really, they were excellent socks. Joan kept them, spoke of them from time to time, toyed even with the idea of posting him a photograph of herself wearing them. I'm not sure what she thought might be achieved by this. In any case, she would not give them back. When about a year later I visited her again in Oxford, she allowed me to wear them once to dinner. Their colour had changed to a sort of chalked mulberry. I guess she has them still.

O O O

Diego's apartment contained a large bed and a small circular table that was awkward for even one person to sit at. The only window, above the bed, looked into a courtyard so narrow that the room

appeared almost as dark by day as it did by night. When I awoke late on the afternoon following my arrival, I had to check the weather online before I could bring myself to go outside in search of a dictionary. Before I left Dublin, I learned a hundred Spanish phrases (*'no puedo quejarse'; 'no entro, ni salgo'; 'puedo escribirlo?'*) but I'd forgotten them upon landing. I was not certain if people still used physical dictionaries, but I felt it was important that I buy one, as a gesture of intent if nothing else. The weather outside was fine: '8°, *despejado'*, according to eltiempo.es. By the time I reached Paseo del Prado, where I thought I could make out the sound of children singing, the weak blue winter sky had darkened and the air had turned noticeably colder. At Plaza de Cibeles, an enormous stage had been erected for a concert in celebration of Epiphany, the Christian feast that marks the visit of *los Reyes Magos* to Christ, the newborn Son of God. I stood in a crowd of young families for a few minutes, watched a child haw happily for his parents, then hurried on – I'm no longer sure in what direction. Uphill, let's say. It was a rough couple of hours. I could not find a dictionary. I could not find a bookshop. I could not even find my way home. Hard to imagine the course I walked that night. Memory takes only a sweeping register of things not related to ourselves: the skaters by the Palacio Real; the fountain at Embajadores; the endless shoe shops near, I think, Bilbao. The topography of these images no longer makes sense to me.

Not until very late did I pass the Telefonicá skyscraper on Gran Vía, close to my brother's old apartment, where I stayed the first time I visited. When, the second time I visited, I tried casually to mention the influence of art nouveau on the neighbouring skyscraper, he responded only that I'd mentioned this the first time.

defection. She hadn't liked that detail. It had ruined the story for her. She found the idea of artists switching movements, as someone might switch phone companies, distasteful. I think that she did not like groups. What surprised me was how unthinking this process of omission became. I was never conscious of what I would not say until I heard myself not saying it. In the weeks before I left Dublin, I slept with two friends I probably shouldn't have. I guess I did not feel I owed it to Joan not to sleep with anyone. At one point she'd given me more of her time and attention than she'd probably planned to, and I suppose she had recently as well; but not once was I without the sense that another of her long and unannounced periods of silence, of unanswered emails, no calls to speak of, nothing of her except the voice in my head, was approaching once again. Joan wanted no more than whatever it was she had. Anyway, I told her about only one encounter; then, with a mixture of satisfaction and regret, I watched as she tried not to appear hurt.

I had been unable to find a dictionary, but thought the night could in some way be redeemed with the purchase of a Spanish newspaper. It is a measure of the ordeal I felt myself already to have endured that I considered it a success to locate a simple corner shop; but when I approached the man at the till with a copy of *El País* in hand, my grasp not only of Spanish but also of basic non-linguistic social conventions, such as queuing or waiting for change, proved so lacking that he could not have believed I was buying the paper for any other reason than to be pictured with it in order to prove that as of 5 January 2015 I was still alive, if clearly not quite all there. As though to redeem my own honour, I started reading as I walked out of the shop, struggling through

political change in Spain.' Not me. On 31 January, I was in a dark bedroom on my own, watching Steve Bruce's Hull City take a three-nil thumping at home to out-of-form Newcastle United on a patchy internet stream. Bruce was philosophical in defeat. 'Up until Newcastle scored,' he said, 'I thought there wasn't much between us.'

In a bistro not far from the Museo del Prado, I ate my breakfast every day for a week until I realised that the owner, whose eyes behind their thick lenses resembled the startled eyes of a stuffed bird, was referring to me as *el americano* for the enjoyment of his customers, all of whom clearly despised me. For four mornings straight, I sat on a high stool at the counter and mispronounced my order of *tostada de tomate con jamón y un café solo*. From that vantage, I had a good view of the shrunken old man in the corner, whom I watched each day bent over a farm-themed fruit machine, draped in a brown leather jacket that may or may not have once fitted him, steadily losing everything he had with the utmost grace and calm. On the fifth day, he was gone, replaced by a not considerably younger man whose leather jacket was not brown, but black. You could tell within a moment of arriving that this guy did not possess anything like the same poise. The crop had failed, his chickens had not hatched. The simple pleasures of pastoral life were obviously beyond him. He started slamming the machine. He started rocking it. He called out in frustration to the owner, expressing an indecipherable sense of injustice. A tension inapt to the hour surfaced as the owner considered the scene in silence for a moment, then disappeared. Though I did not doubt that he would return soon, I flinched to see him do so with a crowbar in his grip. He hopped over the counter and, spearing the crowbar into

one of its crevices, he tore the front shell from the farm-themed fruit machine, which, it now became clear, was in fact the property of the not considerably younger man, who collected his winnings into a dirty canvas bag and jingle-jangled down the road. He had not been gone long before the shrunken older man returned.

○　○　○

By now one commonplace of emails I sent back to Ireland was that I had never been silent for so long. Of course I knew that this was not the case. Not exactly. It was true I was alone. It was also true I liked being alone a lot less than I'd expected. Some Saturday nights, I would stand on the metro watching as the city simmered underneath, my carriage filling with groups dressed up and buoyant, making their way out somewhere together. Staring at the floor, I pretended to have chosen not to listen in. Most of the time, though, I didn't know what to do with myself. After work, I walked around; or sat on my bed, on my computer. Yet I was far from silent. During the day, I spoke to students, colleagues and disgruntled members of the food services industry. At home I was not silent either. Some thoughts I pronounced, some thoughts I did not. Usually what came out were just snatches of speech: often, 'I don't know about that'; sometimes, 'is that so?' It is not clear to me what or whom I was addressing in these remarks, if that is even what I was doing. For the most part, I figured these enunciations were scraps of language cast into the empty room with no purpose other than to mark time, or remind myself of what I sounded like. Yet lately

it had troubled me to notice that, whenever I tried switching to Spanish, as I often did in those moments I felt shamed by the lack of progress I'd made learning it so far, the first thing I heard was always this: *estamos aquí* – always the same, *estamos aquí*.

'We are here.'

I did not know what to make of that.

<p style="text-align:center">o o o</p>

At work I would often end up talking to a British man, like Ricky Gervais, except with black teeth. In the course of the first week, he had referred to me as British so many times that eventually I had stopped correcting him. I took care not to be asked to go for lunch. Whenever I had a free afternoon, I would say I was going to the Prado. Occasionally this was true. Any time I did go, I would end up looking at the works of Jusepe de Ribera, especially those that were hanging in Room 9. It was not merely that there is a large bench in Room 9 – though the large bench certainly didn't diminish this room's allure; rather, the work of Ribera seemed charged with the kind of dramatic intensity I usually had trouble identifying in Old Masters without first being directed to it. With Ribera, there was no trouble: not with his handsomely bearded St Bartholomew, the saint's enormous reach as he holds to heaven the knife with which he is about to be skinned alive; nor with his apelike St Jerome, hermit patron of translators, beating his own chest in with a rock; and not with St Sebastian either.

<p style="text-align:center">o o o</p>

Mondays and Wednesdays I worked in a school way out in a township called Las Rozas. About forty-five minutes outside Madrid, Las Rozas seemed to me a very strange place. Everything felt very far from everything else; and there were never as many people around as you would have imagined it necessary for the area's many businesses to prosper as apparently they did. There was little to do in Las Rozas. You could hear footsteps from much too far away. The place had about it the feel of a holiday resort in permanent off-season. The playgrounds were empty, the fountains often dry. The first time I took a walk around Las Rozas, it felt like a cruel joke to discover that all its awful streets had been named after famous writers. Calle Pablo Neruda, Calle Gabriel García Márquez, Calle Camilo José Cela: all those tidily desolate streets with nothing of their namesakes except that they were dead.

During the afternoon, the school I worked in took on the characteristics of its surroundings. Sometimes there would be only two teachers in the centre, each idly waiting for their evening students to arrive before they could teach the class and go home. On one of my first afternoons, the other teacher sat opposite me correcting homework. 'What's wrong with this sentence?' he asked. '*Sometimes it isn't always best to tell the truth.*' I had spoken to this teacher once before. He'd come to Spain the previous summer and he seemed not as bad as the black-toothed David Brent. I said something about incompatible adverbs. 'Yeah,' he said, falling silent. The conversation seemed to be at its end, but, as it turned out, it was not. The adverbs seemed beside the point now. In earnest he speculated that sometimes it isn't always best to tell the truth. 'Yeah, like a white lie,' I offered. He shook

his head, told me I wasn't listening to him. 'For example,' he said. 'If a pig gets herself all dressed up for a night out, are you gonna tell her she looks terrible?' I was not certain that I understood his meaning. 'Think about it,' he urged. I gave it a second or two. I said that I supposed not. I think he bared his teeth then. *'Thank you,'* he said finally, returning to his work. Later, standing on a chair trying to look out a high window, he complained about the downtime. He said he couldn't stand how quiet it got.

On the 7.30 p.m. bus out of Las Rozas most Mondays, an old woman would sit four rows from the front, smelling of the same cream as Joan. Sometimes, especially on Mondays, I would think of Joan. The reasons I'd moved to Madrid were numerous and generally amorphous. Some were plainly material. I didn't have a job in Dublin. I never had any money, and was unable to do the things I wanted to do, like going on the piss every night, eating lunch and dinner in restaurants, or moving out of my family home. Others, such as Joan, were less material, and therefore more difficult to grasp. Initially I told myself I left because I wanted to get away from our semi-romantic situation in which something kept not happening, but happening all the same, briefly, and with an intensity that did not give much back in change. I told myself that since there seemed so little chance that things would alter, it was time to leave. It was not until one Monday evening, on the bus out of Las Rozas, where the smell of Joan had made its way down from row four to row five, that I became dimly aware that until that moment I had not understood my intentions at all. In fact, what I'd wanted to do by leaving was make Joan jealous, I think, of my life. I am not sure why. Possibly I was jealous of hers;

possibly for the same reason I'd even bothered telling her I'd slept with one of my friends before leaving: it gave me an unmistakable, though not uncomplicated, feeling of power over her and, perhaps with that, myself. Though I never articulated this desire to myself or to others, I find it is retrievable in clear, if slightly ridiculous, pictorial terms: I'd wanted her to imagine the life I would live in Madrid, a cosmopolitan European city, renting cheaply and within walking distance of several major cultural institutions, through which I would wander, in a manner somehow faintly suggestive of sex having already taken place, with attractive and intelligent Spanish men and women, talking about obscure Spanish painters – no, *sculptors* – of whom Joan had never even heard, but whom she would no doubt dismiss in much the same way as she dismissed anything she did not know: instinctively, often temporarily.

She showed no sign that she might visit.

○ ○ ○

Madrid was the first city I had lived in where everyone returned my gaze, a response I did not immediately realise was so automatic as to be empty of all connotation. Some people stared so long I could have sworn they'd caught their own reflection. What struck me as most strange at first was the physical appearance of the streets. It was not that they were longer, or busier, or even more strikingly decorated, than others I had known; they just seemed much wider. Everywhere I went, I was reminded of places I had never been: Miami, Los Angeles, Vancouver. In parts of the city, especially at junctions, the skyline appeared spacious

to the point of vacancy. At Plaza de Colón, where a total of five streets connect, the centrepiece statue of Christopher Columbus seemed not only dwarfed by the Pez-dispenser postmodernism of the Torres de Colón to the south, but totally engulfed by the large swathes of negative space to the north, west and east. From a height of over fifty metres, Columbus looked like just another old traffic conductor, lonely and anonymous now, his figure further diminished by the appeal it still made to monumentality.

Often I ate lunch not far from Colón, in the Café Comercial on Glorieta de Bilbao, because I had read that it was there that intellectuals ate lunch. Former regulars included Blas de Otero, Gabriel Celaya and Gloria Fuentes, and although these are names that meant less than nothing to me, I saw the cafe had a corner named after Antonio Machado. I had at least heard of him. In 1951, as well, Camilo José Cela, the Nobel Prize-winning dedicatee of the street I worked on in Las Rozas, published a novel set entirely inside the Café Comercial. One morning I spent several hours under the high ceilings of the Biblioteca Nacional, reading the library's only copy of *La Colmena*'s out-of-print English translation. Next to a photo of Cela on the back, one blurb praises the novel – translated as *The Hive* – for what it calls its 'snapshot approach'; but to me its formal qualities seemed closer to cinema than anything else; its narrative panning in and across an ensemble cast of the cafe's patrons. It is like the opening scene of *Boogie Nights*, but instead of a nightclub full of porn stars and pornographers, we have a cafe frequented by melancholic wise-asses trying to borrow cigarettes from each other. The novel, which makes frequent allusions to homosexuality, was banned under Franco.

Downstairs the cafe's large, open-plan interior allowed you to observe everyone more or less discreetly, but I spent most of my time there trying discreetly *to be observed*, reading books, large ones, held at such an angle as to place the title in clear view. I didn't notice many noticing. Most of the patrons looked nothing like intellectuals. They looked like people having affairs. There was, however, one old man of frail distinction who would occasionally sit opposite me, correcting what looked like exams and essays. Sometimes, when our eyes crossed paths, he'd smile.

In certain parts of the cafe, especially near the window where the old man sat, it was possible to tell when a metro was passing underneath by the gentle tremor of its heavy granite tables. I discovered this one afternoon as I sat contemplating a large slice of tortilla that had just been served to me. I have for many years made a point of not eating onion or anything containing onion. It is an absolute refusal that has made many days more difficult for others. My first girlfriend ate a burger once with onion on it. The smell never seemed to leave her breath and shortly afterwards we broke up. Try as I might, I cannot locate an early trauma to account for this aversion. But there in the Café Comercial, at a table near the window, I could see that the large slice of tortilla I sat contemplating contained onion. It definitely contained onion. Not a little onion. Not some onion. Not even a munificent but ultimately removable quantity of onion. The large slice of tortilla I sat contemplating was *threaded through* with onion. The longer I stayed there, the clearer it became that the large slice of tortilla I sat contemplating was in fact *mostly onion*. Probably it would not be going too far to say that there by the window in the Café Comercial I sat contemplating *not*

a large slice of tortilla but a large slice of onion. That afternoon I sat there contemplating for such a long time that I began to fear the old man would think I was attempting, by sheer force of my own gaze, to make the large slice of onion, which he would presumably but misleadingly describe as a large slice of tortilla, *move*. When the table began suddenly to vibrate, I wondered for a moment if it wasn't my doing. The moment passed. I checked my phone, but that was not it either. No one had called. No one would call for some time.

The streets had been hot to walk on last September in Madrid. My brother's first serious relationship had just ended and I'd returned to help bring his bags back. Time passed mostly in grim silence that weekend. On the last day, we were sitting by the fountain in the Puerto del Sol, watching nothing in particular, waiting only for our flight time to draw nearer, when a large man dressed all in leather dragged a small young woman in front of us. The girl was wearing just a bra and denim shorts. She was blindfolded, gagged and handcuffed, and she was groped all over by the enormous man. At length he struggled to remove her bra and shorts until at last she stood there, in the Puerto del Sol, naked save her handcuffs and her blindfold and her gag. On the inside of her thigh she had a tattoo of an angel whose wings reached up as far as her outer labia, which I looked at for long enough to note were shaven and sweating. Then a camera crew appeared, followed by a director, next a large crowd of onlookers, and finally several police cars. The officers were not impressed by whatever permit the crew waved in front of them. The shoot was shut down, everyone involved harangued, and although the director managed eventually to convince the officers not to arrest anyone, for a few minutes it seemed as if the young woman

was going to be removed from one pair of handcuffs only to be placed into another. I mention this only because it was on my mind as I began at last to eat the large slice of tortilla I had contemplated for so long that it was now completely cold. I finished it in three large mouthfuls, hardly chewing at all; and then I sat watching as the residual trail of half-cooked egg on my plate developed a skin.

I remained there, I suppose, for however long it takes for two people, totally silent, three tables and several decades apart, to develop a relationship requiring each to smile in parting. I tried to fix my hair, which wouldn't sit, and I drank another coffee to wash the cold wet egg and onion from my mouth. I remembered telling Joan about that second trip to Madrid: about the naked woman in Sol, about how long it had taken my brother to collect the stuff from his old apartment. I remembered saying that if I ever had the poor taste to write about the end of my brother's relationship, I had the ending ready. That evening at the airport, I said, my brother briefly and unexpectedly perked up to tell me about something he'd seen weeks before, at the same flight gate, as he waited to board a plane back to Dublin for someone's birthday. A Spanish family were standing next to him, he said, the father carrying two large Burger King bags so full up with food that he had hardly set foot inside the jet bridge before he'd let some fries fall out. My brother could not remember if it was a burger, or a sundae, or a ranch crispy chicken wrap that fell next; only that the man became flustered. He just kept letting stuff fall, he said, amazed. By the time he reached the door, the tunnel was a horrifying ruin of beef patties, Coca-Cola, popcorn chicken, the lot. I said to Joan that here my brother's tone had changed to one of which I had no measure. He said that all he had left, then, was salt.

[Put a Man on Its Grave]

Up to their neck in
work we refuse even
to admit, the police
live under a curse,
particularly the
plainclothes men,
who, when seen in
the middle of (and
protected by) the
dark blue uniforms
of the straight
coppers, appear
like thin-skinned,
translucent lice, small
fragile things easily
crushed with a
fingernail, whose
very bodies have
become blue from
feeding off that
other, the dark blue.

— Jean Genet. *Querelle* (trans. Anselm Hollo).

Not long after their arrival in Rome at the start of April 1867, the brothers Edmond and Jules de Goncourt noted, in a journal entry anticipating the style if not the sensibility of Thomas Bernhard, that 'everything that is beautiful here is beautiful in a coarse, material way'. The pair would stay for six weeks, touring the city's galleries with an eye that seemed in no way softened by the languors of travel: Raphael's *Transfiguration* is reported to give the impression of wallpaper, while his *Resurrection* is judged 'purely academic'. 'This, a supernatural event, a divine legend? I know no canvas which depicts it in a commoner prose, a more vulgar beauty.' And it's true: for a recently resurrected body, Raphael's Christ does seem kind of jaded; yet I find myself less interested in the value or the vehemence of the brothers' judgement here than in the way the *Journal* slides, as it often does elsewhere, so casually and without warning, from the first-person *plural* to the first-person *singular*. After their mother's death in 1848, the brothers were apart for more than twenty-four hours on only two occasions. Working together on novels, plays, art criticism and journal entries, Jules would hold the pen while Edmond – eight years the elder – stood behind him, pacing back and forth, leaning over his shoulder with suggestions. 'It is impossible to attribute any entry to one or the other,' their translator notes. Theirs is an *I* containing more than itself. It is a singular pronoun of multitudes. It is a crowd. It is a site of excess.

Left Trouville after
spending twenty
days there, the
worst twenty days
of our lives.
The agony
of being ill and
unable to be ill at
home, of having to
drag one's pain
and weakness
from one place to
another.[22]

[22] *The Journals of Edmond and Jules de Goncourt* (ed. and trans. Robert Baldick).

When the Goncourts visited the Vatican during Holy Week that summer, they were struck by the 'sly ecclesiastical malice' they believed the prelates put into 'humiliating and torturing the foreigner's curiosity'. Sceptics of high standing and sickly dispositions – each one tortured all their life by the other's stomach, liver and nerve complaints – the brothers did not appreciate having to queue outside in the blistering heat of their Roman holiday, sometimes for hours at a time. Once inside the Museo Pio Clementino, however, the two were left awestruck before a two-thousand-year-old fragment of a nude male statue which they refer to as the Vatican *Torso*. Believed to represent Ajax contemplating suicide, the fragment is signed with a name that's mentioned nowhere else in any surviving ancient literature or art: this is all that remains of Apollonius, son of Nestor, his entire output lost except for this, a piece of work that's largely lost as well. The figure has no head or neck or arms, no feet or calves or shins. It has nothing but a squat marble cock-and-balls, two muscular marble thighs, and of course that abdomen, that perfect marble abdomen, created with such sympathy, such skill, that the Goncourts – writing not only in the *Journal*, but in their book of art criticism, *L'Art du 18eme siècle* – would hail the *Torso* as 'the only fragment of art in the world which has given us the complete and absolute feeling of being a work of art'. What got the brothers going here was not the myth of the thing, nor the lyricism of an allegory half told, but rather, the way in which the surface of the represented abdomen – that twisted torso, its muscles tensed – had given them both to imagine the processes taking place beneath it: 'this fragment of breathing chest,' they write, 'these palpitating entrails in this digesting stomach.' For all that's lacking here, for all the ravages of oblivion this body has incurred, what we have is a work of art, a piece of matter, that gives no sense of less – but *more*.

211

The Goncourts returned to Paris just long enough for Théophile Gautier to introduce them to an upscale Champs-Elysées brothel ('its extravagant Renaissance decoration in the worst possible taste') before they headed south again, this time to Vichy, a place where they report 'one loses the illusion that sickness is a distinction'. Nine days into the trip, the brothers find out that the poet François Ponsard has died. Sickness was the spirit of the age, as the *Journal* will reflect when they return to Paris; becoming more and more a catalogue of visits paid by their wealthy friends to the city's many doctors and specialists. Not until the last months of 1869, however, do the horrifying symptoms of tertiary syphilis – a disease contracted by Jules, an enthusiastic patron of brothels, as many as fifteen years before – show up in the text, finally. It takes hold of it.

A little later in the century, syphilis would manage to acquire what Susan Sontag described as 'darkly positive associations' – a whole artistic mythos concerning feverish mental states and creative spells – but such glamour had yet to attach itself to the disease when Jules first noticed the early tell-tale chancre. His affliction is never named as anything more specific than a *nervous illness*, but the brothers would have had a pretty clear sense, not only of what the disease was, but of the hell it was about to visit upon Jules. In 1867 – after two years in a semi-paralytic state, no longer capable of understanding language, much less of formulating it – Charles Baudelaire had died in a *maison de santé*, ruined by the disease.

Only one more entry is made after 10 January before the pen falls from Jules's hand: a long final showing in which it is reported that, in the late stages of his own nervous illness, the composer Vaucorbeil had developed a horror of all things velvet. *My poor nervous system* is the last instance of Jules using the first person singular outside quotations: *our* lives, *one's* pain, *our* friends, but *my* poor nervous system. The switch to the first person singular seems far less casual here than usual. For here their *I* splits open and becomes discrete. Here sickness *is* a distinction. For once it is clearly Jules who is speaking, who is speaking *in* and *of* and *for* himself; who is *screaming*, desperate to make one last mark that's all his own, a single phrase will suffice, a fragment to survive him, a figure with no neck or head, no arms or feet or shins, no excess and yet *more*. For the next six months, Jules will continue to read aloud, more and more obsessively, from Chateaubriand's *Memoires d'outre-tombe*, oblivious to his brother's growing indifference to it, but still oppressively conscious of his own decline. By June, Jules has forgotten the name of every book they have written together, yet he remains lucid enough to feel shame. On Saturday 11 June, Jules manoeuvres a bowl clumsily in a restaurant. *It's not my fault,* he cries across the table, where in tears he continues with cryptic incoherence: *I know how it upsets you, but I often want to and I can't.* The following weekend, on 18 June, Jules will suffer a stroke that leaves him bedridden for two days: his body thrashing round in horrifying pain, sleepless and mute, his mind haunted by some apparition in the curtain which he does not have the words to describe. *A disintegration of the brain has occurred at the base of the skull,* says the doctor. Not till the second stroke hits him will he die.

9.00 a.m.	9.00 p.m.	9.40 p.m.
All night long, that rasping sound of breathing like the sound of a saw cutting through wet wood, punctuated every now and then by heart-rending groans and plaintive cries. All night long, that beating and heaving of his chest against the sheet.	I touch his hands: they are like moist marble.	He is dying, he has died. God be praised, he died after two or three gentle breaths, like a child falling asleep. How frightful is the immobility of this body under the sheets, no longer rising and falling with the gentle movement of respiration, no longer living the life of sleep.[26]

[26] *The Journals of Edmond and Jules de Goncourt.*

That *rasping* chest. Those hands *like marble*. *The immobility of his body under the sheets.* These states and textures make me think of the *Torso* which the brothers so admired. 'A sublime work of art,' they called it, 'which derives its beauty from the living representation of life.' Gruesome and horrific though it may be, Edmond de Goncourt's account of his brother's death-agony is an unquestionably beautiful work. Since its existence was a secret to everyone until 1883, it is difficult, maybe impossible, to date it exactly. In the italicised passage just after Jules's final entry, Edmond is no more specific than to tell us that it had been 'an interval of many months' before he took up 'the pen fallen from my brother's fingers'. For at least nine months in any case, the immediacy that so marked the writing of the first nineteen years is lost, sacrificed in the service of 'recounting to myself the story of his death-agony and despair'. These sheets in which Jules dies are backdated: the work of memory, moments recollected with the help of notes jotted down during nights of distress and so 'comparable to those cries by which we relieve the pain of great physical suffering'. Inscribed into these lines is the echo of that suffering, those cries. For now, the *I* that speaks inside them is a voice in which there lurks an absence, something that *was* there but *is* not; a voice grown echoic in its own emptiness. These sheets derive their beauty from *the deathly representation of dying*. Here is an account of a death, told by a voice that holds this death inside it.

[Cracking Up]

I can't

 u

 n

 t

 w

 i

 s

 t

the cord

ten times

just because
of Munich
or whatever
it was. Let it

stay tangled.

— Ingeborg Bachmann. *Malina.*

It was past four in the morning when I got back to my room in the flat which for some months I had been sharing with a furtive young Puerto Rican theologian. I turned on the lamp and sat down at my desk. I stared through the layer of dust and the spattering of food stains on the black screen of my laptop. In the reflection I saw that for once my hair was sitting just the way I liked it. I poured a tumbler full of Rioja, a wine I did not like but drank a lot of at the time, turned my laptop on, took off my jeans, my socks and shirt, and then, in just a pair of boxer briefs, dark-blue with thin white stripes, got down to the business of resigning without notice. I had already been drafting the email for a couple of days when I began to read it now, out loud, for misspellings, typos, run-ons and contradictions. Addressed to the director, this roughly drafted email announced, in just over five hundred words, that I would not be returning to work on Monday. 'I'm sorry to email you during the weekend,' I intoned towards a row of bad Ribera print-offs tacked to the wall, hearing an unsteadiness of tone in my voice, a sort of shorthand for sentiment that I recognised as my father's reading voice. Out loud I told myself, 'Cut that stupid fucking lilt of yours, because this ain't funny, pal.' This was serious: 'I'm sorry to email you during the weekend,' I repeated, much flatter now. 'I realise that it's your time off, and that anything I say can only cause you stress. It has been weeks since I slept for more than an hour, and lately I've been feeling on the verge of cracking up.'

One Sunday afternoon a couple of months earlier, I walked over to Elanor's place for lunch – another English teacher who lived with her Spanish boyfriend, Salvador, in a large high-rise

apartment at the top of Calle del Doctor Esquerdo, the steepest four-lane road that I have ever seen. Before moving to Madrid I had promised myself that I wouldn't hang out with anyone that I would not hang out with back in Dublin. I knew you had to be careful with expats – one midweek drink with a persistently outgoing weirdo at work and next thing you know you're going for mountain hikes every other weekend with a cohort from the local expat Facebook group. Then late one evening I got a message from Elanor, explaining she was a friend of a friend and inviting me for a drink with her and her boyfriend. I liked them a lot and for a while they took me in. I'd never spent so much time with one couple. That Sunday, after dinnertime, Salvador got a call from his uncle, who said he was parked outside and to come down. '*Venga*,' he said to Elanor, then turned to me. 'Come.' Outside I was introduced to his uncle and his aunt. His uncle said a couple of words in broken English and then I said a couple of words in broken Spanish and everyone pretended to find this whole scene more amusing than it probably was. His uncle and aunt were downsizing, Salvador explained, as his uncle opened the boot of his car to reveal a large black chest of drawers turned on its side. Salvador smiled as we lifted it from the car towards the building. The lift, as he suspected, was too small to take what he called his new baroque furniture. There were Chinese-style figures in bas-relief along the side. 'Okay,' he said, puffing his cheeks while contemplating the stairs, 'I'll do the backwards part.' By the time we'd edged the chest up all seven flights, it was dark outside. His uncle had arrived back with the chest from a trip to China in the mid-eighties, Salvador

recalled. Elanor said she wasn't sure about it. She said it didn't really suit the room, or even fit inside; but it was something Salvador had wanted since he was a boy and each time he went to the kitchen to get more wine, I watched him brush his fingers along the top of it. It was about three in the morning when I left, walking down Calle del Doctor Esquerdo, where the traffic lights went green to red to green and not a single car went by.

The harsh light from my reading lamp cast such dramatic shadows on my desk that I had trouble paying attention to the resignation draft on my screen. There were forty-nine unread messages in my work email's inbox, an address that for the most part received only ignorable group messages from the director and unrefusable requests to cover classes for absent teachers at short notice. It was not an inbox I was often pleased to have checked, but occasionally there would be an email from Alfonso, a cheerful, perma-stubbled electronics engineer whom I taught every Friday night, and this would contain links to various newspaper articles about Francisco Nicolás Gómez Iglesias, a twenty-year-old from Madrid who had recently become notorious when he was arrested for forging official documents and passing himself off as an adviser to the deputy prime minister, the secret service and the Royal Household, where in June the previous year he'd managed to gain entry to the reception that followed the new king's coronation. In a widely circulated photograph, Felipe VI is shown greeting Little Nicholas, whose slickly gelled head is bowed to con-

ceal a grin of just-contained laughter. I recall a synchrony of sighs the first time Alfonso mentioned his name in class. Little Nicholas had become an almost constant presence on the afternoon television circuit, the other students said.

Elanor was at the ticket office when I arrived at the entrance of the Cine Doré, a small art nouveau cinema and archive built on Calle de Santa Isabel in 1923, which in emails home I frequently referred to, with knowing inaccuracy, as the Cinemateca, hoping to evoke some soft-focus image of myself, sitting rapt in luminous darkness, like Michael Pitt in the opening scenes of Bertolucci's terrible *The Dreamers*, set in Henri Langlois's 1960s Cinémathèque Française. 'Long time no see,' said Elanor, handing me a ticket for a Buster Keaton film I had recommended we go watch. 'Sal can't come cos he has to work, but he's invited you round later, if you want.' In the lobby of the building, whose linoleum-grey layout was in counterpoint to the ostentatious exterior facade, we each ordered a glass of vermouth and sat down on seats that felt more suited to a school canteen than a 117-year-old listed building. 'How was South America?' The question had not landed before I decided to rephrase it. 'Wait, no,' I said, squinting slightly. 'How was the WWOOFing?' I felt the lower half of my face twist into a smile when I made this sound, a present participle made from the acronym of the organisation that had facilitated Elanor's placement for the last two months

on several organic farms in South America. I'd found the term amusing ever since I first heard her say it, but I worked my face back into a neutral expression as soon as I'd remembered the offence Elanor seemed to take at this amusement, which I am fairly sure she thought was grounded in the conviction that tourist farm labour was a risible bourgeois pursuit. And I suppose, in a way, it probably was. But no. That really wasn't it. I just thought it sounded funny: *WWOOFing*, I repeated to myself; all I thought was *dogging*. 'Great,' she said, ignoring my insolence. 'Lots of volcanoes and mountains and shit. Not sure if it went really quickly or really slowly.' When I asked if she'd had much spare time, she laughed. In the evenings on one of the farms she worked at in Chile, she'd done a lot of sitting by herself on the porch of a distant cabin, the only place on the property with wi-fi strong enough to stream a Channel 4 sitcom on her phone. I told her I found this image unbearably moving, but there are only so many times you can use those two words together before people stop believing them.

Eighteen blades of light sliced through the shutter, and for a while my room lost shape. The email I was writing to the director was not the first time I'd complained of nervous collapse. 'I'm – fever – crazed,' I'd stammered down the phone on a friend's couch in Dublin one Monday in 2013. 'I'm not – can't – talking.' I'd been unable to formulate a proper sen-

that he'd landed up in hospital several times. One
evening he confided in me that five years before,
a neighbour had discovered him passed out on the
front lawn of his parents' house. He said those had
been his wild and terrible years and they hadn't
stopped until one summer night when, after inhaling
a particularly strong dose of the stuff, he lay down
on his bed, took off his trousers, switched on his lap-
top and streamed pornography until such time as the
devil appeared to him. 'He had a body,' he told me.
'He had arms and legs,' he said. 'But his face . . . his
face was the pornography.' As I passed the kitchen
door, he called my name. 'I went to *Sevilla* last week,'
he said, refusing to anglicise the city where, not long
before, having heard it might be cheap enough to
live there without a job, I told him I was planning
to move once my lease ran out in midsummer. He
raised the sandwich to his mouth. 'Strange voices,'
he said, chewing. 'So hard to understand.'

A couple of priests, collared but in casual dress,
stood up from their seats at the table opposite
Elanor and me, prompting her to check the time.
'This is about to start,' she said, suggesting that
we sit upstairs on the old-style balcony where,
in the front row, almost as soon as we sat down,
I took off my shoes and through my thin black
socks gripped hold of, with my toes, an ornate

swirl on the heavy iron railing. 'Mate,' she whispered as the film began, with a shot of Buster Keaton looking much the same as ever in the role of Alfred Butler, the effete son of what, judging by the size and splendour of the drawing room he sat in, was clearly a wealthy family. 'What?' I whispered back, unsure if she meant me or him. 'Your feet,' she said, as the doleful look on Alfred's face was interrupted by the film's first intertitle. 'Get a camping outfit,' that intertitle read, giving voice to Alfred's father. 'Go out and rough it. Maybe it will make a man out of you if have to take care of yourself for a while.' At this the film cut back to Alfred on the couch, doleful and silent as ever. 'They're fucking rank.' 'Fuck you,' I whispered, my toes strengthening their grip.

When I'd signed the lease on the room on Calle de Granada, with George and his Bibles across the hall, I had done so because of its relative proximity to the Museo Reina Sofia. In the afternoons of early May, however, when I experienced the heat outside as an almost spatial property, I tended not to walk to the museum but to take the metro, for I told myself the air was cooler and more comfortable down there, though in truth it was much worse: too close, almost airless. One of

my former students, a friendly retiree named Monica, lived with her husband on the street between my place and the Reina Sofia; and the fear of being seen by them, or any of the two hundred-odd other students I'd been teaching regularly, even the children, who presumably had parents, influenced my behaviour more than I liked to admit. I'd covered almost nothing I was supposed to, and I doubted anyone I'd taught bore much chance of passing their exams. When the metro pulled into the platform, I looked, as I tended to do, beyond my own reflection, peering far into each carriage to ensure that I would not be stuck in such a cramped space with anyone I even thought I recognised. Boarding an almost empty carriage near the back, I sat down opposite a middle-aged man with long hair, wrap-around shades and a Guns & Roses T-shirt. I picked up a discarded paper. Little Nicholas was in the news again. He'd been arrested for running out on a €500 restaurant bill, but no charges had been made. He was planning to run for parliament now. Things seemed to be going good for the guy, I thought getting off the train. They were going pretty good for me too, I told myself, leaving the Atocha station and waiting for the traffic lights to change.

smoothly and with a minimum of stress,
conflict or even civilised debate, which
I often come out of looking stupid. The
third was watching, with another person,
a movie that I'd seen before and had for
some reason recommended. As someone
whose sense of identity and self-worth
has for years been grounded in the con-
spicuous and frequently unfelt enjoy-
ment of high culture, this way of looking
was the one about which I'd had most
opportunity to think, and about which I
found myself thinking once again as I sat
with Elanor in the front row on the bal-
cony, my toes gripped onto the front rail-
ing, watching a silent film that she knew
I'd seen already. There in the darkness of
the Cine Doré, I was no more attentive
to Alfred Butler than Alfred Butler was
to firearm safety. I was looking straight
ahead, but it was Elanor I was watching.
Or, rather, it was Elanor I felt myself
watching *as*. Which is to say that it was
Elanor, some hypercritical approxima-
tion of her, that I was watching myself
as. I was looking straight ahead of me,
but with my right ear and the edge of
my right eye, with the whole right side

of my body in fact, the toes of my right
foot included, I was watching out for
signs of her approval. Finding none, I felt
myself judged. 'Some prize fighter has
taken your name, sir,' the intertitle read,
before a close-up shot of a photo of a
boxer on the front page of the newspaper.
I grew restless, feverish. The film seemed
a lot less funny now than I recalled.
Christ, I thought. Did I really like this
first time round? What time is it? How
long is left? Drawing my feet back from
the railing, I edged my phone out of my
pocket. Over an hour, I saw. Squirming
and much inclined to leave, I crossed my
legs, uncrossed them, clenching my teeth
as I pledged never to recommend another
film again, never to talk about another
film, or think about another film, or even
watch another film again, when Butler,
after no more than a single date with the
mountain girl, announced that he would
like to marry her, and Elanor let out a
laugh, an actual laugh, and I turned to
find that she was smiling.

At exactly 9.09 a.m., the sound
of an incoming email alert shook

me from the half-sleep into
which I'd fallen and my elbows,
both lodged into the window
frame, were forced forward so
abruptly that the skin on each
was shredded. I wheeled my
chair across the room, picking up
a sock to stem the flow of blood.
On the other side of the wall,
just above the threshold of the
audible, I could hear the plaintive
sound of George practising the
chorus of David Guetta's 'Tita-
nium' on his unplugged electric
guitar. I squeezed my eyes open,
shook my head and then looked
back at the screen. Not only was
the email still unsent; the ending,
the part I worried about, had yet
to be drafted. On top of that, I
now had fifty unread messages.
'I don't know how long I will be
back in Dublin,' I wrote. Then
I stopped. Was there not some
other, more ambiguous, way of
phrasing this? The crisp clang-
ing of George's guitar, coming
in under the door, was starting

to grate. It was just past nine in the morning. And on the weekend. What the hell was he doing playing his guitar so early? Shouldn't he be at Mass or something? I stood up. I opened the door. I slammed it shut. The playing stopped. I deleted 'I don't know how long I will be back in Dublin', picking up the sock again to pat my elbows dry; then I pinched the skin around my eyes, digging out the sleep dried into them. I puffed my cheeks out and exhaled. Then I began to type once more: 'I don't know how long I will be off away in Dublin, but certainly too long to think about continuing to work at English Language Place.'

The Reina Sofia, which functioned as a hospital before it eventually reopened as a museum, seemed such a large and imposing building as to wipe every other structure on Plaza Emperador Carlos

V from memory and possibly even consciousness. In all the times I went there I did not seem to register the existence of anything else in the square, with the exception, that is, of the tall grey steps leading up to the museum, where a bunch of interchangeable skaters with weirdly stylish mullets sat smoking weed beside their portable speakers playing old electro-indie hits, mostly by MGMT. As I skipped past them, not looking but looking all the same, I felt my hand sweep through my hair, and I wondered who or what I thought I was, exactly. Something that I'd obviously been aware of before I quit, but of which I hadn't really taken stock until after, was that on my newly idle afternoons all my friends would be busy with their own jobs. I raised a single and some-

how apologetic finger to the man at the ticket office. '*Sí,*' I said, pushing a handful of coins beneath the glass. '*Una solo.*' When I passed security, I turned right, following the high ceiling of the stone-laid corridor until I came to Room 1, where an exhibition of some hundred-plus modernist pieces on loan from the Kunstmuseum in Basel had been running since March. Among the borrowed paintings there was a single Mondrian grid, a composition in white, black and red that seemed more modest and, if possible, more reticent than the few I'd seen before. In one of the notebooks that he kept as his work began to approach full abstraction, Mondrian asked: 'Rembrandt, are we going wrong or aren't we?' The stress does not fall kindly here, and I have often wondered about the translation,

but in the spring of 2011,
when I first read this line, I
remember feeling strangely
reassured to know that a fig-
ure of Mondrian's eminence
had been burdened by this
weight of doubt. The work
seemed so assured of itself. I
kept a look out for this ten-
sion. I liked the strict division
of parts and the way these
parts seemed to balance, with-
out me knowing how or why.
What I liked to look at most,
however, was the white, the
off-whiteness of the white,
his brittle, brittle white, shot
through with cracks, like al-
most every grid by Mondrian,
who, as his style developed,
had rejected oil-based paint
in favour of a petroleum sol-
vent which, though disastrous
in conservation terms, dried
much quicker on the canvas,
allowing him to work at his
own hurried pace. My reflec-
tion was not visible on the

glass, and so I looked beyond it, beyond the glass, into the scarring of impatience, strewn across a canvas on which emotion had been disavowed.

'These people will never know the difference,' the screen read. 'The champion will win and no one will ever hear of Battling Butler again.' The impish valet had drawn Alfred Butler into the well-furnished interior of their woodland marquee to explain the lie he'd had to tell to get the mountain family onside. Out of the corner of my eye, I saw Elanor stand up and leave. To go to the bathroom, I assumed, but who could say. Not infrequently, I am told that I'm the strange one for announcing whenever I'm about to use the bathroom. But it seems much stranger not to, to silently stand up,

turn around and walk off
with no clear sense of when
or if you intend on coming
back. After a few minutes,
though, Elanor did come
back. Leaning in close to
my ear, she said she'd had
to take a call and asked me
what she'd missed. 'Well,'
I whispered. 'Big sur-
prise. The newspaper got
it wrong. Battling Butler
beat the champion and now
Keaton's gotta pretend to
the girl and the in-laws that
he's the new champion.'
'They got married?' 'Yeah,
sorry, just there. After
he returned triumphant.'
'Fucking idiots believing
that. Where are they driv-
ing anyway?' Several rows
back, someone shushed
us. On a dusty road in the
middle of nowhere on the
screen, the mountain girl
appeared and flagged the
car down, taking Keaton

and his valet by surprise. 'I'll say nothing,' I said, staring straight ahead.

One night I went to Mass. Let's say a humour took me. It would probably do me good, I thought, for my Spanish or whatever. '*Redentor mío, me pesa de todo corazón haberos ofendido*,' I repeated, in increasingly exaggerated tones, as I snaked across the park, where darkness stole from thickening trees, towards the Portada de San Jerónimo, a sixteenth-century Gothic structure, chalk-white and luminous in the sun, but inside cold, even murky. I sat down on an empty pew not far from the altar, where several members of a television crew were rolling up

thick television wires,
whistling back and forth
to one another, shouting
out instructions less than
reverently, taking their
goddamn time. Sitting on
her own in the chancel to
the right of the Portada
de San Jerónimo, a pros-
perous old lady with an
ashen face and crimson
hat met my gaze, and
together we shared a
quiet look of wearied dis-
approval at the unkempt
roadies in the television
crew. Under a red cape,
a cardinal came out,
apologising for the long
delay, saying something
I could not quite follow
about the church and this
modern world we live
in. He cracked a joke, or
so it seemed, for I'd lost
the train of what he was
saying; I was wonder-
ing what I'd have to do,

exactly, to wind up in
that woman's will. *Per-
dona, perdona. El mundo
moderno.* He cracked
another joke, it seemed;
then started to *perdona,
perdona* once more. I
tried to catch the wom-
an's eye, but no such luck
this time; and when I
turned back to the altar,
the cardinal was gone,
replaced by a lesser cler-
ic, a bog-standard priest,
who instructed the con-
gregation to stand before
continuing, incredibly, to
apologise. '*Perdona* this,
perdona that,' he said,
though not, I finally re-
alised, for the delay, but
for the shame of man.
At this small misun-
derstanding I smiled, a
private smile, intended to
be seen, and as I turned
once more towards the
prosperous old lady, I no-

ticed, to my surprise, not
to say horror, that stand-
ing just behind her was
Alfonso, the follower of
Little Nicholas, who I'd
left unprepared for their
exams, after months
of convivially running
down the clock in class.
He'd noticed me already,
I think, for no sooner
had I seen him than he'd
caught hold of my eye,
raised both his eyebrows
and smiled.

The back entrance of
the park was so close
to where I lived that
I could go there most
evenings, confident that
nobody I knew from
work would see me
getting there or getting
back, or sitting on the
bench I always sat on,
contemplating the same
view, always the same

one, of the Torre de Va-
lencia, a granite-brown
brutalist skyscraper
on the corner of Calle
O'Donnell, just outside
the park, framed by a
fortuitous arrangement
of trees within it. With
darkly cavernous balco-
nies rising up along its
body, like the rungs on
a ladder, or the minor
keys of a piano on its
side, the tower seemed
at once monumental
and discreet, modern
in a way that was not
coming back. The Torre
de Valencia was just
under a hundred me-
tres tall – I checked –
and continued to reflect
sunlight for as long
as two hours after the
trees in the park had
left me in the shade.
So consistent was its
texture and its colour,

ings on Avenida del Mediterráneo blocked out the falling sun entirely. Yet since I knew it was here that the retiree I used to teach still lived, I flicked my sunglasses off my head and over my eyes. Feeling a knot in my left shoulder, I told Elanor I'd spent a lot of the last few days lying in my room in the dark, with a week-long headache, or possibly a migraine, I didn't know. 'I think it could be the light,' I said. 'I'm not exactly sure.' 'Have you been stressed or something?' Ela-

nor asked. 'Not
really,' I told her.
'I sleep till three
in the afternoon.
I've nothing to
be stressed about.
Except the head-
aches, I guess.'

The birds had
stopped singing
by the time
George shut
up. Someone
across the way
was unloading
a dishwasher,
but otherwise
the room was
at peace. A chill
rushed through
me and I real-
ised that I had
been sitting
in my boxer
shorts for much
longer than
I'd anticipated.

The email was
almost finished,
but I stood up
for a moment
to put on pyja-
mas and go to
the bathroom.
'*Buenas*,' I said
as I passed the
sitting room,
where George
was slouched
on the sofa
watching a
flashy TV quiz
show. '*Buenas*,'
he replied, as
I passed him
coming back.
In my room, I
looked at my
laptop and sat
down for about
five seconds.
My body is too
tired for this, I
thought. I stood
up and when

I pulled the
shutters down,
the room went
dark again. I
unplugged my
laptop and got
underneath
the bed sheets.
'I'm very sor-
ry to do this
without giving
any notice,' I
typed, my lap-
top sitting on
my stomach,
'especially at
this point in
the academic
year. But I can't
put my job be-
fore my health.
Thank you for
your support
in the last four
months. Yours
sincerely, Kevin
Breathnach.'
I hesitated

said.
Elanor had
wandered
into the
kitchen, but
the door was
open and we
could both
hear that she
was laughing
in there.
'Kev was just
in the middle
of telling me
he's started
going to
church,' she
called out.
Salvador
turned and
looked at me
curiously.
'*A, sí?*' he
said. 'You are
becoming
religious?'
'No, no,' I
said. 'I just

commu-
nion on
my knees.
He said
he'd heard
that some
Spanish
church
leaders
had re-
cently
instructed
that this
was the
only prop-
er way of
doing it.
'No,' I told
him, paus-
ing for a
moment
before I
started to
explain
that, about
halfway
through
the ser-

vice, on
the other
side of the
church, I'd
seen a for-
mer stu-
dent and
I'd frozen.
'For the
rest of the
Mass,' I
laughed, 'I
didn't turn
so much
as an inch
in his di-
recti
on.'
Elanor
walked
into the
room and
sat down
next to
Salvador,
her back
to the
window,

had made
during
Mass, so
that Ela-
nor and
Salvador
would
have a
better
sense of
what I
meant.
This
went on
a while,
perhaps
a full
minute,
perhaps
a full
hour. My
stom-
ach had
grown
sore with
laughter
before
their

twin
stillness
struck
me and I
stopped.
The sun-
less sky
behind
them ap-
peared to
hold its
breath.
I took
another
bite of
my burg-
er. 'You
have a
good
view,'
I said,
chewing
it slow-
ly, my
hands
clasped
upturned
in my

Sources

Credits

'Not I' was first published on *Fallow Media*; 'Not II' was first broadcast on RTÉ Radio 1 and was later published in *The Tangerine*; 'Tunnel Vision', 'Unfamiliar Angles' and 'Resurrections' were all first published in the *Dublin Review*; 'Closer Still' was first published on *Response to a Request*; 'But I Did That To Myself' and 'Cracking Up' were both first published on *Granta* (online); 'The Lot' was first published in *The White Review*; and 'Put a Man on Its Grave' was first published in *The Bodies that Remain*.

Special thanks to T.V. editor Lee Brackstone, to T.V. assistant editor Ella Griffiths, to T.V. sub-editor Eleanor Rees, to T.V. cover artist Jonathan Pelham, and to T.V. layout designer Paul Baillie-Lane. Special thanks to T.V. agent Lucy Luck. Thanks to the Irish Arts Council for supporting T.V. with an Emerging Writer's Bursary in 2015. Thanks to the Irish Writers' Centre as well. Special thanks to Brendan Barrington and Rebecca O'Dwyer for their editorial work on pre-T.V. versions of these essays. Thanks as well to Luke Browne, Emmy Beber, Tara McEvoy, Luke Neima, Jacques Testard, Ben Eastham, Eimear Walshe, Regan Hutchins and Ian Maleney for their work on other pre-T.V. versions. Special thanks to Eimear Walshe, Rebecca O'Dwyer, Michael Nolan, Tara McEvoy, Morgan MacIntyre, David Tapley, Salvatore Fullam, Dennis Harvey, Lily Ní Dhomhnaill, Darragh McCausland, Ross, Conor and Joan for their friendship and T.V guidance. Special thanks as well to Eimear Walshe, Nicola Creighton, David Scott and Mary Norris for their teaching and influence, without which I could not have written T.V.

Very special thanks to Salvatore of Lucan, Saint Sister and Tandem Felix for their art and T.V. company. Very very special thanks to my wonderful family, for their love, understanding, protection and humour. Extra special thanks to Colette and Conor and Joan, and